Communication
Design

Communication Design

Principles,

Methods,

AND PRACTICE

Jorge Frascara

ALLWORTH PRESS
NEW YORK

10 09 08 07 06 6 5 4 3 2

Published by Allworth Press
An imprint of Allworth Communications, Inc.
10 East 23rd Street, New York, NY 10010

Cover design by Derek Bacchus
Page design, composition, and typography by Sharp Des!gns, Lansing, MI

LIBRARY OF CONGRESS CATALOGING-IN-PUBLICATION DATA
Frascara, Jorge.
Communication design : principles, methods, and practice / Jorge Frascara.
 p. cm.
ISBN: 1-58115-365-1
 Includes bibliographical references and index.
1. Commercial art. 2. Graphic arts. 3. Visual communication. I. Title.
NC997.F695 2004
741.6—dc22
 2004018346

Printed in Canada

To my wife, Guillermina Noël

Contents

Acknowledgments

I OWE WHAT I AM TO ALL THOSE WHO, SOME-
how or other, have had a profound effect on my life.
Sometimes through an influential sentence, sometimes
through years shared, sometimes through their work.
Herbert Spencer taught me to do field research in a
forty-five-minute conversation in 1974. In another
forty-five-minute conversation ten years later, Paul
Rand made me see the value of looking at one's own
work with a critical eye. At a conference in Zurich in
1977, Richard Saul Wurman said two things that stuck
in my mind because of their clarity and directness.
When it comes to being clear and direct, I keep on
learning from Ronald Shakespear and from Gérard
Paris-Clavel. Working with Tom Nelson has been a
permanent source of learning and joy. The work of
Armin Hofmann and Juan Carlos Distéfano made
me think about form, back in the 1960s. Tomás
Maldonado taught me the value of always being
vigilant and informed. Rubén Fontana, the power of
tenacity and humility. From Juan Carrera I learned to

think critically, to put things together and to take them apart, to see the patterns that connect, as Gregory Bateson would put it. Bernd Meurer made me discover different ways of looking at everything: the principles behind the instances of design action. To Ronald Davey I owe a sensitivity to precision in language and a huge debt for my coming to Canada.

I owe lots of joy and learning to Steve Heller, John Aston, Peter Kneebone, Willy DeMajo, Susumu Sakane, Marijke Singer, Paul Stiff, Paul Mijksenaar, Erskine Childers, Dietmar Winkler, Sharon Poggenpohl, Karel van der Waarde, David Sless, and many others. And the list keeps on growing. The references in this book show authors to whom I owe many ideas, as well as to others I do not explicitly cite, such as Anthony Wilden, Gilles Deleuze, and Felix Guatari. To my colleagues Sue Colberg and Bonnie Sadler Takach, my thanks for their support and their continuing friendship. My wife, Guillermina Noël, taught me how valuable and enjoyable all these things can be, and continues to keep me vigilant about everything I say. I thank Nicole Potter and Tad Crawford at Allworth Press for the opportunity to make this work public.

Introduction

THIS BOOK IS INTENDED TO OUTLINE THE field of communication design, its areas of concern, its working methods, and its purposes. It is directed at visual communication design students (not at experienced designers) and includes discussions of some areas that are bound to grow and change in this era of information explosion and technological innovation.

The demand for designers is greater than ever. This is particularly true because of the fast development of new communication technologies and the need to pay attention to human factors that are outside the expertise of computer scientists. Beyond recognizing this phenomenon as a context, this book centers on visual communication design as a human communication problem—not as a technological problem—and focuses on essential aspects of the profession and of the education of designers.

This book will point out important issues in the profession, but does not claim to provide a comprehensive survey. More than defining boundaries, it intends to identify relevant issues and their impact on the practice.

Some subjects have been developed more than others. This is sometimes because of the greater experience of the author in certain areas; sometimes because a given problem is more important than others; and sometimes because certain topics have, to a great extent, been left out by most of the literature.

The book is written in plain language, avoiding the neologisms and jargon that often create a mystique about certain problems, and make the statements appear more scientific or sophisticated than they actually are. This fictitious scientism or pretentious language produces a false sense of certainty that reduces the complexity, scope, and richness of visual communication design problems. Hence this book has more descriptions than definitions, and its vocabulary is not extensive.

There are several reasons why terms from linguistics do not appear often in this book: The visual language does not have finite dictionaries or glossaries, and therefore the linguistic duality of signifier/signified is inapplicable. The interpreter plays a more decisive role when looking at images than when reading or hearing words, and the power of contexts adds another element of uncertainty to the visual language. I prefer to say "organization" rather than "syntax" (although

"syntax" might appear here and there), because "syntax" is a special kind of organization, applied to verbal sequences, in which a series of rules govern sentence structure. The term "organization" is broader and more appropriate for visual communications because it confronts the reader with the infinite possibilities of elements and arrangements, instead of creating the notion of limitation that the word "syntax" denotes.

Elements from rhetoric could have been discussed if the book dealt more with a linguistics-based theory of communication, but this is not the purpose of this text. It is, instead, directed at discussing visual communication design from the experience of a practitioner and with a social sciences–oriented point of view.

Comments and criticism are welcome.

JORGE FRASCARA

Department of Art and Design
University of Alberta
Edmonton, Alberta, T6G 2C9
Canada
frascara@ualberta.ca

A Description
of the Field

THE TERM "VISUAL COMMUNICATION DESIGN" IS
subject to a long series of interpretations. The different
definitions of the word "design" in everyday language
have contributed to a lack of precision in understand-
ing the job of the visual communication designer.
Design is generally understood as the physical product
derived from the activity, but the activity itself is often
overlooked. Expressions such as "the beautiful designs
of aboriginal fabrics" incorrectly use the term "design"
instead of more appropriate terms like "ornaments,"
"decorations," or "patterns." People also speak of the
beauty of the designs that the waves leave on the
beach, or other natural forms. When a profession's
name includes a word that refers as much to a natural
object as to an activity and an industrial product, there
will certainly be confusion in the minds of many.

Whereas the public tends to perceive "design" as
referring to objects, designers tend to center the word
on action, and see the product as a final step in a long
journey. To design, for the contemporary designer, is

an intentional activity. It is connected to neither the marks on the beach nor the repetition of a traditional ornamentation. To design is to invent, to project, to program, to coordinate a long list of human and technical factors, to translate the invisible into the visible, and to communicate. It involves judgment calls, the implementation of knowledge, the generation of new knowledge, and the use of educated intuition and decision-making. In this book, the word "design" will be used to refer to the process of conceiving, planning, projecting, coordinating, selecting, and organizing a series of elements— normally textual and visual—for the creation of visual communications. The word "design" will also be used in relation to the objects created by that process. The words "visual communication" modify the word "design," and relate it to the production of visual objects aimed at communicating specific messages.

The three words put together, "visual communication design," overflow the sum of their individual meanings to become the name of a profession whose description is in part the aim of this book. To propose a working definition for now, I would say that visual communication design, seen as an activity, is the action of conceiving, programming, projecting, and realizing visual communications that are usually produced through industrial means and are aimed at broadcasting specific messages to specific sectors of the public. This is done with a view toward having an impact on the public's knowledge, attitudes, or behavior in an intended direction. A graphic design is an object created by that activity (Gorb 6).

Design and Communication

The visual communication designer works on the interpretation, organization, and visual presentation of messages. Sensitivity toward form should go hand in hand with sensitivity toward content. Publication designers organize not only typography but also words. Their work concentrates on the effectiveness, appropriateness, beauty, and economy of the messages. This job, beyond cosmetics, has to do with the planning and structuring, production, and evaluation of communications.

The Designer and Other Professionals

Rarely does the communication designer work with text-free images. In advertising, the writer is in most cases a key member of the communication team. In other areas, such as the design of books and book covers, a preexisting text drives the content to be visualized.

In many cases, the designer requires contributions from photographers, illustrators, animators, computer programmers, calligraphers, and draftsmen; other specialists who are less connected to the design profession are often needed as well, depending on the content and the audience of a given project. The designer must consider equally the communicational strategy and its realization the way a music conductor must know the range of the instruments without

necessarily knowing how to play them all. Fundamentally, the designer's job is that of a coordinator. Visual communication designers coordinate research, conception, and realization, hiring specialists and using information related to the needs of each project.

Given that the job of the designers includes interacting with other specialists, they must have an ability to work in interdisciplinary teams and to establish good interpersonal relations. In the final analysis, designers are specialists in human communication, and their specific medium is visual.

"Graphic Design" versus "Visual Communication Design"

It is necessary to recognize that the term "graphic designer" has contributed to the obscure profile of the profession. Although better than "graphic artist" and far better than "artist," the term still places too much emphasis on the graphic, physical element and omits more essential aspects of the profession—the main aim of which is not the creation of graphic forms but the creation of effective communications. Although the most widely accepted term is indeed "graphic designer," it is more descriptive and appropriate to say "visual communication designer," because this definition includes three essential elements of the profession: a method (design); an objective (communication); and a medium (vision).

The Presence of the Designer in the Message

Designers—as opposed to artists—are not normally the source of the messages that they communicate. In addition, and again as opposed to artists, the job of communication designers must normally be free of the personal presence of the author. This is done to avoid noise in communications that are expected to put clients in touch with their intended audience. Another example from music clarifies this point: According to an article published by the *New York Times,* a newly appointed conductor of the Philadelphia Symphony Orchestra had trouble persuading the musicians that the orchestra was supposed to be concerned with quality, not with identity. The previous conductor had tried to develop a distinct style during his tenure. The central problem, the new conductor argued, was not to obtain a "Philadelphia sound," but the sound of Haydn, or Beethoven, or Stravinsky, or whomever the composer to be interpreted might be.

While it is commonplace to recognize the creator of a painting by its style, it is not desirable to recognize designers through their work, particularly when their presence creates noise in the interpretation of a message. Posters designed by famous artists—like many produced for the Lincoln Center film festivals— can lend prestige to an institution, but recognizable styles tend to call more attention to the authors than to what the posters announce. In this situation, noise is created in the communicational process—however beautiful the poster could be. The content the posters

mean to communicate is reduced to a secondary role. This is not a rare occurrence. When famous artists are invited to design posters for cultural events, they tend to produce images that basically represent their own work. This has happened many times with posters designed by painters such as by Frank Stella, Josef Albers, Andy Warhol, and Roy Lichtenstein. Josef Müller-Brockmann's film poster, by contrast, shows an appropriate solution to a similar problem, since it visualizes the notions of movement and filmstrip through an intelligent typographic play of transparency. The tonal atmosphere is also an appropriate reference to the movie theater experience (Figure 1).

A poster by Albers that announces a show by Albers would be quite fitting. What in one context may be noise, in another may be information.

Information, Redundancy, and Noise

The three concepts—information, redundancy, and noise—come from information science and help to clarify some communication design problems.

The concept of "information" is connected to novelty, which relates to the level of novelty present in a message. The level of information in a message is in inverse relation to its probability. "The main axiom of [information] theory is that the information carried by one signal in a string of signals—say a word in a sentence—is an inverse function of the probability of

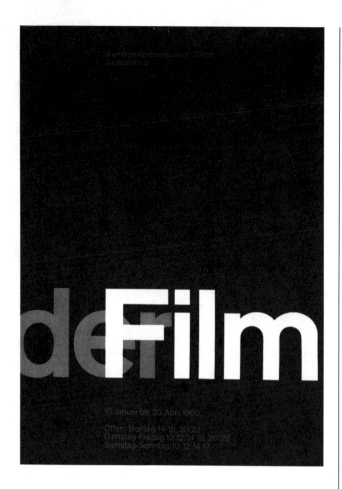

1. Josef Müller-Brockmann (1960), *Der Film*, poster. (Reproduced by permission, © Shizuko Müller-Yoshikawa)

that signal occurring in that context. Thus if I say 'good morning' at breakfast I may mumble the first word without much being lost on you: in that context the word has high probability and therefore low information value" (Petit 22). Therefore, for example, a detergent's package that reads "New formula" might provide information, but this becomes redundant if all detergents on the market include the same claim, and it gets lost in the context.

The connoted information in the example is that "new formula" implies that the product is (a) better than the previous one, and (b) better than competing brands. When competing brands also state that they have a new, and better, formula, the messages cancel each other out and become "This detergent is similar to all other detergents" and, possibly, "This 'new formula' claim is not even true, and if it is, it is not necessarily better." This shows the complexity of communication processes and the presence of information in relation to expectations and redundancy.

On the positive side, "redundancy" has at least two functions: insistence and clarification. Insistence, in the form of repetition, is a rhetorical strategy that, when properly used, can lead to a better memorization of the information, while giving prominence to a message. Many people end up believing whatever is sufficiently repeated. The use of repetition as clarification often happens when the same information is presented in different ways—sometimes using different coding systems—to ensure that the information will be understood by a good number of different people. In some cases, this strategy might generate noise, when certain target groups become distracted by the presence of codes they do not understand.

"Noise" is any distraction that appears between the information and the public, thereby interfering with, distorting, obliterating, or hiding the message. In the case of communication design, noise can appear at a purely visual level, because of elements or techniques

that obscure the visibility of the stimuli presenting the information. It can also be caused at a semantic level, when the logic of the message does not match the cognitive culture of its intended audience.

Noise can exist in the channel (medium), the code (language), or the form (aesthetics or style). Noise is created by irrelevant information, obliterating elements, or poor technical quality. The consequence of noise can range from a lack of clarity to the total incomprehensibility of a message.

Reality and Creativity

"Within this view, designers would appear as guides, as advisors, that, supported by extensive practice and experience, would provide users and decision-makers with the originality of their analysis, their creativity, and their realism." With these words, J. Mullender, former director of the Centre of Industrial Creation of France identified important aspects of the designer's role back in 1979: originality of analysis, creativity, and realism. Indeed, a good balance between creativity and realism is missing in many artists' posters for the Lincoln Center film festivals.

Creativity in design must exist within established limitations. Total freedom should not be taken as an essential condition to permit creativity, and creativity should not be seen as pertaining exclusively to the arts. Creativity can be defined as the ability to

conceive unexpected solutions to apparently unsolvable problems. Without magic or mysterious touches, creativity is nothing other than intelligence— an intelligence that, in certain ways, can be developed and that, in the midst of a flood of unconnected and chaotic data, allows one to discover connections that others do not discover, see differences that others do not see, and, as a consequence, produce new and surprising integrations (Hofstadter 26).

The alleged opposition between creativity and realism has no grounds except to those people whose romantic conceptions link creativity with Van Gogh's madness or Utrillo's excessive drinking. Creativity—although requiring uncommon skills—is based on a number of controllable processes, such as observation, attention, research, and analysis, and, to a certain extent, on the possession of thinking strategies that combine flexibility with efficiency.

Creativity and Communication

The duality of "creativity and communication" cannot be stated as an opposition. Clarity is not opposed to creativity in communication design. Creativity can make complex messages easy to understand, and the lack of it can render simple messages obscure.

The belief that clarity is opposed to creativity is based on misconceptions about both creativity and design:

Creativity in design has nothing to do with self-expression and an indulgent egocentrism. It requires, instead, an objective and flexible intelligence, an ability to analyze any problem from a multiplicity of viewpoints, so as to be able to understand the intentions of a client (the originator of the message), and the possible perceptions that a wide range of sectors of the public could have of a given message.

The creativity of the designer is similar to that of the actor who, working in different genres, addresses various audiences and makes diverse literary creations come alive on stage.

Communication and Aesthetics

Communication and aesthetics are not in opposition, either. The visual communication design problem cannot be seen as a need to choose between communication and aesthetics, because aesthetics is a communication requirement to be satisfied in communication design. Beauty and visual sophistication are important dimensions of the work of the designer, but they must be integrated within the project's content and its public, and cannot be dealt with on the basis of allegedly universal and context-independent criteria. This topic will be discussed later in the section on aesthetics.

The Main Purpose of Visual Communication Design

Every piece of communication design arises from the need to communicate a specific message, and to obtain a desired response; in other words, it comes to exist because someone wants to say something to someone else, so that this someone else does something in particular. This is why one cannot judge the quality of a design only on the basis of its visual appearance. The aesthetic aspects that affect the selection of some designs in juried exhibitions and in history books should not distort the evaluation of the main purpose of visual communication design, which centers on generating a certain response from a certain public. It seems, however, that some designers conceive their pieces with design exhibitions and books in mind, to the detriment of the clarity, effectiveness, and appropriateness of the material produced. Although some designs can become ornaments, historical documents, or aesthetic paradigms—once they've accomplished their primary goal—visual communication design is not just about looks; it is fundamentally about performance.

Sometimes, the concern for originality and beauty has contributed to the development of visual sophistication and cultural value, but it has not promoted the communicational function of design, and has often distracted designers from the fundamental purpose of their work. Many examples of this can be found in the avant-garde work of the 1920s.

To understand visual communication design properly, we have to think more about actions than about objects. The emphasis should not be on the product, given that this is only a means. Essentially, the designer generates the communication by designing an event, an act in which the public interacts with the design. The objective of the designer is, therefore, the design of communicational situations. Further, the important issue is not the communicational act itself, but the impact that this has on the knowledge, the attitudes, and the behavior of people. This makes clear the need to study the interaction between messages and people, not only the interaction of visual elements with one another, which has absorbed the attention of designers so much in the past. Visual composition is important, but it is only a tool, a way of organizing the communicational event. This communicational event happens over time—not only in space—and is loaded with complex human elements related to language, experience, age, knowledge, education, memory, cognitive style, preferences, expectations, desires, and other perceptual, intellectual, social, cultural, and emotional dimensions. In sum, the purpose of communication design is to affect the knowledge, attitudes, and behavior of people— something that happens after the communication takes place.

Historical Context

A BRIEF HISTORICAL SURVEY WILL HELP US
see the development of the definition of visual
communication design as both an activity and a public
perception issue. The perception of the visual
communication designer as being distinct from the
artist developed after the beginning of the twentieth
century, and it has continued to change ever since.
The conception presented in this book centers on an
understanding that has evolved in the last fifty years,
when the notion of visual communication design as art
gave way to a growing interest in communicational
issues, ranging from cognitive psychology to marketing.
It could be argued that graphic communications with
specific objectives have been developing for 25,000
years. Working methods, allied fields, and educational
requirements to practice the profession are such,
however, that one cannot identify the communication
designer of today with the caveman warlock from
Altamira, the sixteenth-century woodcutter, or the
1890s lithographer (Figures 2, 3, and 4).

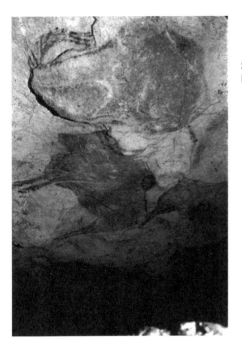

2. Cave painting, Altamira, Santander, Spain.
Photo: Jorge Frascara.

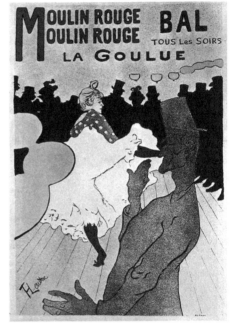

4. Henri de Toulouse-Lautrec (1891), *Moulin Rouge*, color lithograph.

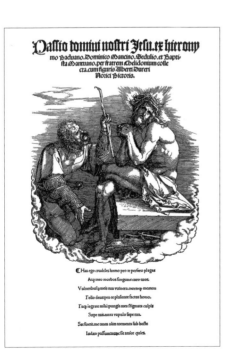

3. Albrecht Dürer (1510), *Mocking Christ,* woodcut, from a series of five engravings to complete the Great Passion.

Whereas prehistoric people completed their work within small and integrated human groups in which graphic communication was part of a social continuum, the designer of today communicates messages through mass media, has no control over the final communicational act, and addresses a variety of groups whose backgrounds, views, and intentions are only partly known.

The sixteenth-century woodcutter is closer to the lithographer of the 1890s than the lithographer is to today's designer. In the former cases, the author was defined more as a craftsman, and formal/stylistic choices were highly embedded in current styles, without conscious consideration of target audiences, subject matter, or implementation context.

Today, the communicational requirements of a project can be met by adopting a given visual style that can be selected from a wide variety. This requires from the designer a conscious control over selection criteria that are based not on personal preferences but on an analysis of the contexts where the communication will operate.

The Nineteenth Century

During the nineteenth century, and up until the beginning of World War I, the conception of visual communications was entrusted to one of two professional groups: artists or printers. Often these

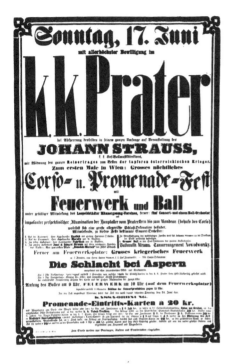

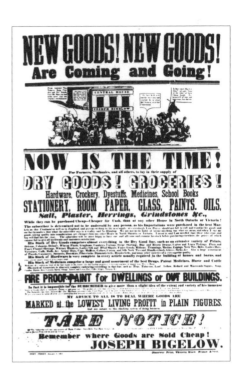

5. (*left*) A. Eurich (1866), *K. K. Prater,* poster.

6. (*right*) Anonymous (1861), *New Goods! New Goods!,* poster.

professionals came from different departments in the same schools of arts and crafts. The printer frequently saw art in the use of ornaments and in the combination of different typefaces, styles, and sizes (Figures 5 and 6).

The artists saw typography as a secondary element and paid more attention to ornaments and illustrations, although in many cases lettering and image were quite well integrated (Figures 7–11). Graphic art in this period is characterized by revivals (neoclassical, neogothic), and by the eclecticism of the turn of the

century. The extreme typographic variations that characterize much of the work of the nineteenth century, however, have not disappeared, as one can see in many of today's publications.

Interest in ornamentation and in typographic variations as marks of good design was a common feature in the second half of the nineteenth century. Art nouveau, with its defined stylistic choices, grew in importance until about 1920. It maintained a high degree of complexity—typical of the nineteenth century—while preserving a strong visual coherence,

7. L. Elsinger (1896), *Bauernball,* poster.

continued on page 21

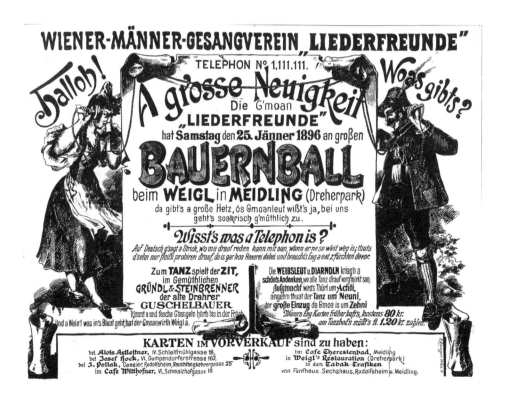

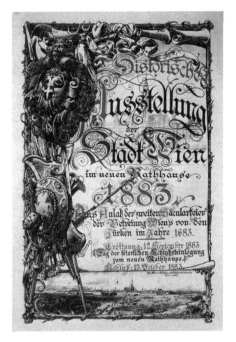

8. Anonymous (1883), *Historisches Austellung Stadt Wien* (Historic Exhibition of Vienna).

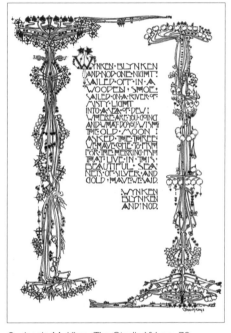

9. Jessie M. King, *The Studio* XV, no. 70 (January 1899): 278.

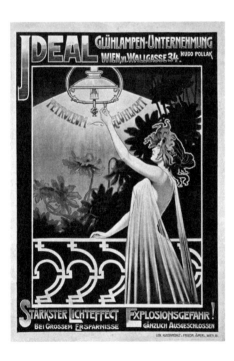

10. E. Döcker (1899), *Ideal* (lamp), poster.

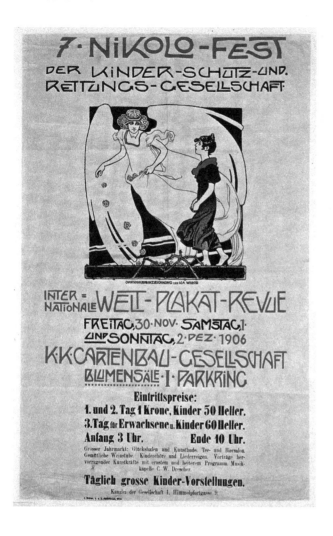

11. K. A. Wilke (1906), *Nikolo-Fest,* poster.

eliminating the excessive typographic variety that characterized most communication design of the 1880s. In this sense, art nouveau represents a move toward high visual order (Figures 12 and 13). In the case of several designers of the time, the style became very simple and free of ornament, heralding some forms of modernism that were to be developed later on.

12 and 13. Art nouveau–style illustrations published by the magazine *The Studio*, founded in 1893.

The Twentieth Century

The artistic movements of the 1910s and the political agitation that accompanied them (including the Russian Revolution and World War I) had a decisive influence on visual communication design. Dada, de Stijl, suprematism, cubism, constructivism, futurism, and the Bauhaus created a new vision that affected all branches of art and design, particularly during the 1920s (Figures 14–19).

These styles opposed the decorative arts of their time, as well as art nouveau, whose visual vocabulary—due to a new interest in geometry—evolved toward art

deco. The work by Peter Behrens for the AEG predates Bauhaus and represents a far more comprehensive understanding of communication design and the idea of identity (Figure 20). Working at the beginning of the century, his work was not well known internationally, but it represents one of the very first—if not *the* first—attempts at an integrated identity for a corporation. Behrens was a kind of universal designer, serving AEG as both architect and graphic designer. Walter Gropius was surely aware of his work, and must have learned much from it.

The avant-garde movements mentioned before were born from a revisionist spirit that permeated all artistic activities of the time. The second decade of the twentieth century shows a proliferation not only of

14. (*left*) El Lissitzky (1925), title page of the book *The Isms of Art*. Constructivism in typography.

15. (*right*) Theo van Doesburg (1922), cover for the magazine *Mecano*. Between Dada and de Stijl.

continued on page 26

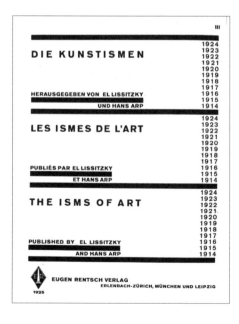

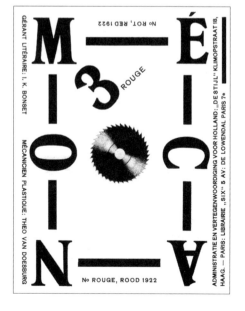

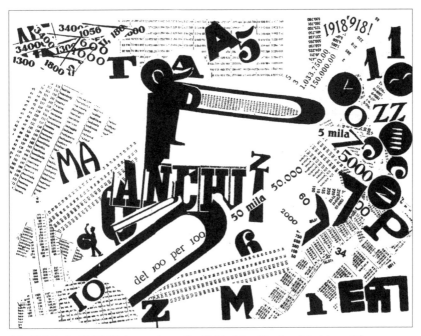

16. F. T. Marinetti (1919), *Les mots en liberté futuristes* (The free futurist words).

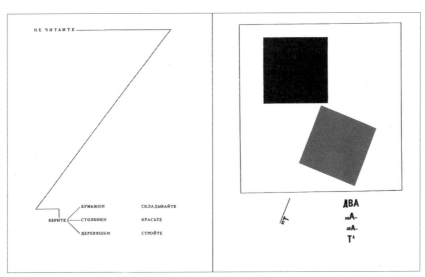

17. El Lissitzky (1920), *Two Squares,* double spread of a tale ("Don't read . . . take paper, lines, cubes . . . arrange them, paint them, construct . . .").

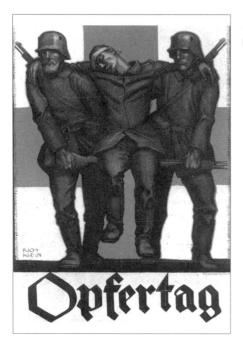

18. Richard Klein (1918), *Opfertag* (Sacrifice Day), Munich.

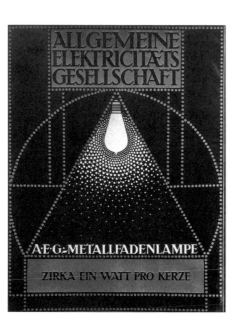

19. Ludwig Hohlwein (1936), *Deutsche Lufthansa,* poster on the occasion of the 1936 Berlin Olympic Games.

20. Peter Behrens (1910), poster for AEG, Berlin. Graphics at the beginning of the twentieth century were not necessarily art nouveau or avant-garde.

new artistic styles but also of manifestos and publications through which artists, designers, architects, and educators expressed their positions.

Two important changes were initiated at the time. One was the change in graphic style, reacting against ornamental eclecticism by proposing a more geometric and minimalist style. This new style, related to constructivism, suprematism, neo-plasticism, de Stijl, and part of the Bauhaus, had a long-lasting impact on the development of visual communication design for much of the twentieth century. The other important element introduced at this time was the use of graphic elements as communicational devices. This appeared as much in designs produced by the expressive dadaists as by others who were fundamentally constructivists, such as the members of de Stijl.

The free typographic layout of the cover of *Der Dada*, published in Berlin in 1919, immediately expressed the spirit of the movement, its irrational character, its search for freedom, and its opposition to issues of the time, particularly current visual styles. The dadaists used the visual structure of their messages to express their artistic convictions; the same was done by the artists of de Stijl. The logotype designed by Theo van Doesburg in 1917 (sometimes attributed to Vilmas Huszar) clearly communicates the group's approach to geometry and formal rigor (Figure 21).

Although the connection found here between form and content appears to be in line with our conception of giving form to communication today, this

DE STIJL

connection fails when those designers work for a third party. In these cases, the presence of the designer in the design turns into noise, such as in the case of Kurt Schwitters's 1924 advertisement for Pelikan ink (Figure 22).

The ad looks more like a promotion for constructivism than for Pelikan ink. The ink jars look like

21. Theo van Doesburg (1917), *De Stijl*, logo.

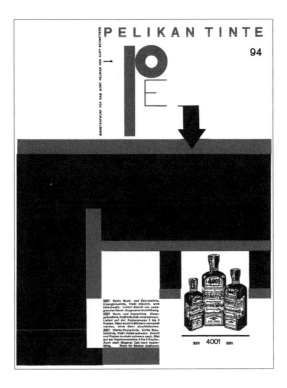

22. Kurt Schwitters (1924), advertisement for Pelikan ink.

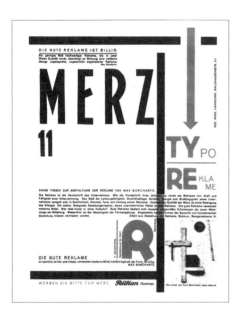

23. Kurt Schwitters (1924), *Merz*, magazine cover.

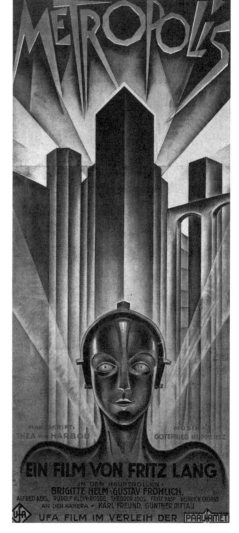

24. Schulz-Neudamm (1926), *Metropolis,* by Fritz Lang, film poster, Germany. Art deco enters communication design.

incidental elements totally unconnected with the environment that surrounds them. The design of the ad does not connect with the visual identity of the product and its calligraphic components. There isn't even an implied relation to the use of the drawing inks. The *Merz* cover, by contrast, is a case where graphic style is perfectly pertinent. It is an occasion for Schwitters to create in freedom. The cover for *Merz* is a good expression of constructivist design. The interest in form and style above everything else is evident even in the small reproduction of a sculptural relief, also made by Schwitters (Figure 23).

The concern for content was not missing altogether at the time. The Schulz-Neudamm 1926 poster for *Metropolis* represents a strong concern for appropriateness of visual language to message content (Figure 24).

Despite examples like the Pelikan ink advertisement, the 1920s produced a positive revision of advertising design, calling for an approach based more on communication than on aesthetics alone. The designs by Moholy-Nagy for the Bauhaus, for instance, show a remarkable reduction in visual noise and a growing interest in legibility and clarity (Figure 25). A notion of functionality begins to develop, often creating tension between functionality and aesthetic preferences.

The alphabet designed by Edward Johnston in 1916 for the London Underground did not achieve the notoriety that surrounded the visual explorations of his colleagues on the European continent. His work,

25. L. Moholy-Nagy (1925), title page for a book published by Bauhaus.

ABCDEFGHIJKLMNOPQRSTUVWXYZ
abcdefghijklmnopqrstuvwxyz
&£1234567890.,;:-!?'""""/()

30pt London Transport Johnston's Railway Type

26. Edward Johnston (1916), British Railways typeface.

however, is more connected to today's practice—at least with regard to information design—than that of the others (Figure 26). His typeface is an enduring example of a design that centers on fitness to purpose.

Jan Tschichold is possibly the first designer who constantly confronts typographic composition as a functional problem centered on the organization of

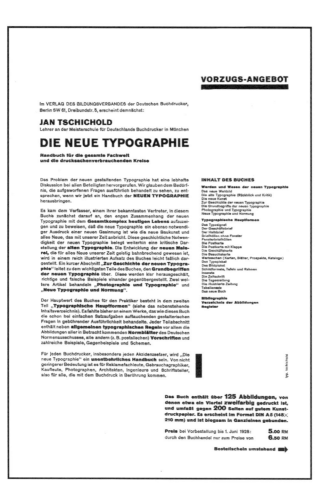

messages. Aesthetics, albeit not ignored, is placed in
the service of communication. Groupings, sequences,
and hierarchies in the text derive from an analysis of
the contents of the messages and contribute to the
presentation of an organized reading (Figure 27).

It is true that Tschichold's contribution owes much to
the constructivists who came before, and particularly

27. Jan Tschichold (1928),
promotion for *The New
Typography* (yellow ground
in the original).

to El Lissitzky, but the use of these new visual elements acquires in Tschichold a consistently functional character that is new, particularly in the treatment of long texts.

The Design of Typefaces

In the 1920s and 1930s, the best-known designers did not explore new concepts in the specific field of alphabet design, but did explore new forms. Herbert Bayer is a clear example of this interest in form, and in the principles of unity and simplicity. The Bayer alphabet (initially named Universal) is based on straight lines and arcs of circle that attain a high formal coherence and, through economy of visual elements, achieve maximum visual simplicity.

The concepts of coherence, economy, and simplicity were strongly appreciated at the Bauhaus, whose members viewed them as naturally related to beauty and functionality. We can see now, however, that it was a certain idea of beauty that led to the conception of those bases for design and not just the idea of functionality. In the case of the alphabet, for instance, differences between letters are indispensable to facilitate reading, but Bayer opted instead for an extreme similarity in pursuit of formal coherence.

It seems that, at a certain moment, a function-centered methodology in industrial and architectural design resulted in the creation of formally simple

solutions. Later, however, simplicity became a stylistic choice, and some of the Bauhaus's designers, who had initially arrived at simplicity in search of functional solutions, went on to create simple-looking visual solutions that appeared to be functional. What at first was a consequence of a certain methodology turned into an aesthetic preference later on.

Bayer's alphabet could be taken as an example of this phenomenon, but it must be remembered in his defense that knowledge about legibility was poor at the time. It could also be argued that Bayer applied certain aspects of new typographic design to his alphabet in an attempt—however failed—to improve its performance. Indications about the development of knowledge of legibility can be found in the bibliography that Herbert Spencer published in his 1969 book *The Visible Word*. Only sixty-four of the 464 entries listed appeared before 1925 (when Bayer designed his Universal font). Miles Tinker's ninety-seven publications on legibility, which are more connected to the work of the type designer than most other former entries, were published between 1926 and 1955.

Simplicity and Quality: The 1950s

The idea of simplicity as a condition for good design continued for many years, not only in alphabet design but also in other areas. The search for visual simplicity affected all communication areas in design during the avant-garde era of the 1950s. This trend, however, did not benefit design performance in some areas, such as the design of teaching aids. In their research developed

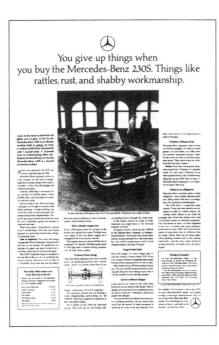

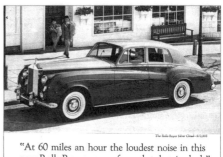

28. (*left*) David Ogilvy, advertisement for Mercedes Benz (Ogilvy 11).

29. (*right*) David Ogilvy, advertisement for Rolls-Royce (Ogilvy 10).

at Reading University (UK), Smith and Watkins demonstrated that there is no reliable connection between design simplicity and efficiency in the communication of information. In a related field, illustration for children's books in the 1950s embraced a simple and plain style that did not really respond to children's preferences (Ladan and Frascara 20). Around that time, consumer product advertising used reduced texts to allow the development of simpler advertisements, which ended up being less effective because of the lack of information. It is useful to read David Ogilvy, one of the most influential advertising executives from the 1960s to the 1980s. He promoted the usefulness of long, informative texts in his campaigns with excellent success (Figures 28 and 29).

In the 1950s, when legibility became a common concern, it was agreed that simplicity was not only equivalent to quality but also made texts and images more legible. One of the more highly affected areas was the design of graphic symbols; instead of working toward augmenting their informational power, designers concentrated on achieving the most extreme simplification. Later on, research demonstrated that the visual simplification of graphic symbols does not increase their legibility, let alone their comprehensibility, not even in non-frontal vision situations (Figures 30 and 31). To sum up, coherence and simplicity in alphabets designed in the 1920s were based fundamentally on aesthetic preferences and not on well-grounded legibility research.

Simplicity is not really the determining factor in legibility. In legibility, one of the main objectives is to avoid confusion, understanding the alphabet as a

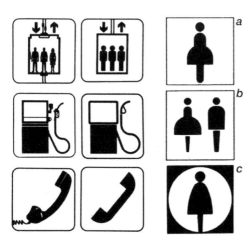

30. (*left*) J. Frascara and A. Hallmayer, testing symbols, 1975. The two versions of the three referents represented obtained the same recognition scores in exposures of one-tenth of a second from three different distances and seven visual angles. Stylistic variations that some designers claim help legibility do not really show differences in performance under controlled testing conditions.

31. (*right*) Simplification in some cases reaches incredible extremes. The bell image (a) actually means toilet for women (Australian Civil Aviation). Along the same lines, image (b) shows the design developed for the 1964 Tokyo Olympics. Image (c) was created for the Tokyo Airport.

system of distinctions in which each component is clearly different from the rest. This principle is not only applicable to reading by adults but also has extraordinary importance in learning to read and write, where the frequent mistakes children make are the result of exchanges based on similarity, inversion, and rotation.

The interest Herbert Bayer had in simplicity over legibility (aesthetics over functionality) is proved by his elimination of capitals. His text designs— including the book on his own work, published in 1967, and the catalogue he designed for the Bauhaus traveling exhibition in 1971—exclude capitals, making it difficult for the reader to identify proper names, and the beginning of a sentence after a period. This reduces ease and speed in reading and comprehension, without offering compensation other than the presence of a text with a highly homogeneous texture. Presumably, he did this as a reaction to the use of capitals in the German language, where all nouns are capitalized.

These characteristics in Bayer's work show up in the work of other designers of the 1920s and 1930s but are not common elements in mass production. They are clear examples of the preoccupations and methodological positions of the avant-garde designers of the time.

In the mid-1950s, research in social sciences had a visible impact on communication design. This may have been due to research on human factors

conducted during World War II, aimed at maximizing human performance in the military. Important areas connected to communication design are experimental psychology (studies of perception, learning, and behavior); social psychology (studies in cultural trends, statistics, and behavior); research on perception, communications, learning, and behavior for the armed forces; marketing research for advertising agencies and consumer products manufacturers; and research in linguistics, rhetoric, and semiotics. This interaction, and especially the studies of perception applied to legibility, initiated new trends in design in general, and in alphabet design in particular. Classic examples of these years are Max Miedinger's Helvetica (Haas foundry, 1956) and Adrian Frutiger's Univers (Lumitype-Photon, 1955) (Figures 32 and 33).

At this point, the concepts of unity of form and geometric simplicity as criteria for good typographic design were, if not totally discarded, subordinated to

32. (*top*) Max Miedinger (1956), Helvetica typeface, Haas.

33. (*bottom*) Adrian Frutiger (1955), Univers typeface, Lumitype-Photon. These alphabets represent a reaction against the geometric construction of other sans-serif alphabets, such as Futura by Renner.

ABCDEFGHIJKLMNOPQRSTUVWXYZ
abcdefghijklmnopqrstuvwxyz
1234567890

ABCDEFGHIJKLMNOPQRSTUVWXYZ
abcdefghijklmnopqrstuvwxyz
1234567890

research-based legibility criteria. In this way, more efficient typographic solutions were developed; one such solution was the importance given to letter differentiation within the alphabet over and above the system's unity and simplicity.

Higher-letter differentiation not only facilitates the letters' individual recognition but also contributes to the creation of more differentiated configurations between words. This facilitates the job of the reader, who does not read letter by letter but word by word, and sometimes by word groups too, through saccadic eye movements and brief fixations.

The design of Helvetica and Univers integrates the typographic knowledge and tradition developed by Leonardo, Dürer, Bembo, Griffo, and especially Claude Garamond, as proved by his roman alphabet, which he designed around 1544. This tradition was interrupted during Bayer and Renner's times of geometric explorations, possibly intending to purge typographic design of the ornamental elements that eclecticism and art nouveau had introduced by the end of the nineteenth century (Figures 34 and 35).

Many of the subtleties of typographic fonts in the 1950s are present in the tradition outlined above; however, the innovations introduced are important enough to recognize the beginning of a new generation in alphabet design in Helvetica and Univers, which are used here as examples from their category because of their massive international adoption during the 1960s and 1970s.

ABCDEFGHIJKLMNOPQRSTUVWXYZ
abcdefghijklmnopqrstuvwxyz
1234567890

ABCDEFGHIJKLMNOPQRSTUVWXYZ
abcdefghijklmnopqrstuvwxyz
1234567890

The purpose of this book is not to explain alphabet design history in detail, but to provide a clear example of the evolution of the interests and general working methods in design. Among the elements that Helvetica and Univers take from the typographic tradition, we can list a series of optical adjustments intended to generate a higher reading fluidity and a higher homogeneity in the tone of words and sentences.

One basic aspect of the approach to font design in the 1950s was paying attention to the typographic shape as a perceived shape rather than as a physical one. This is commonly known as optical corrections. The adjustments made to the basic typographic form served to compensate for optical illusions that negatively affect the perception of a letter.

To maintain consistency in perceived size, for example, triangular and circular letters are drawn

continued on page 41

34. (*top*) Claude Garamond (c. 1544), Garamond typeface, Linotype version.

35. (*bottom*) Paul Renner (1927), Futura typeface.

36. Curves in letters extend beyond the base lines and the height of square letters.

37. The middle horizontal strokes are placed above the geometric half of the letter. This optical correction is designed to make the horizontal stroke appear as if it were in the middle.

38. Vertical strokes are thicker than horizontal ones. (See comparison between the horizontal stroke of an E and the vertical of an N.) This correction comes from the architectural tradition and experience, where columns that support are expected to be thicker than the supported roofs.

39. The thickness of the curved strokes varies, following the principle explained in the caption for Figure 38; that is, horizontal sections are thinner.

40. The shape of the curve is not geometrically regular.

41. The joints between verticals and diagonals are corrected to avoid creating large black areas.

higher than the rest. Among other adjustments, the middle horizontal lines are placed above the geometric middle. The thickness of the lines varies in relation to the direction they have: verticals that visually represent support are thicker than horizontals; middle horizontals are thinner than the ones on the top or base; and oblique lines are thicker than the horizontals. Oblique and vertical lines get thinner when they converge. This is done to avoid big black areas where strokes meet at an acute angle. The thickness of curved lines varies constantly, and they are never drawn as geometric arcs of circles. This serves to handle visual forces in a less mechanical way, and with more fluidity (Figures 36–41).

Another aspect that is affected in the new typefaces of the 1950s is the uppercase/lowercase proportion. Many of the characteristics discussed above are already present in eighteenth-century alphabets, but an original aspect in typography from the 1950s is the growth in lowercase height, compared with that of capitals. This relation changes from a 5:8 proportion, established by Renaissance alphabets based on the Golden Section, to a 6:8 proportion, adopted for intended functional reasons, and not for aesthetic ones.

The Golden Section is a very unique proportion, in which the first factor is to the second as the second is to the addition of the preceding two. This creates the possibility for a continuous growth of elements with very strong relations to one another. The numerical relation is 1:1.618 (1.618 being the first digits of a never-ending irrational number), and is represented

Ex *Ex*

dd ee gg

42. (top) The height of the lowercase letters in fonts designed after 1950 is greater than in the classic alphabets (6:8 instead of 5:8).

43. (bottom) The descenders in fonts designed after 1950 are slightly shorter than those in the classic alphabets. This is done to permit a larger face within the point size.

geometrically by the side and the diagonal of a regular pentagon. Fibonacci, an early Renaissance mathematician, developed the simplified version of this proportion, creating the series of numbers 5, 8, 13, 21, 34, etc., as a way of facilitating the use of proportions considered beautiful or aesthetically pleasing.

The change in proportion introduced in the 1950s, together with the shortening of descenders in lower-case letters, allows for a higher lowercase size in a given typographic measure, attaining better legibility based on a more efficient use of the space (Figures 42 and 43).

This change, however, renders texts too dense, and requires extra leading, resulting ultimately in a cancellation of the advantage initially sought. Legibility relates not only to the size of the letters but also to the spaces that separate letters and lines from one another.

Font Design since the 1950s

Another aspect that places these typographic fonts in a new context is the systematization of the variables—light, medium, and bold; roman and italics; and condensed and expanded. Adrian Frutiger developed twenty-one variations for his Univers, starting with the roman medium (Univers 55) and creating the extremes, from the ultra bold expanded at one end to the ultra light condensed at the other (Univers 83 and 39, respectively). This notion of system characterizes the font design of the 1950s (Figure 44).

44. Adrian Frutiger: The twenty-one variations of the Univers typeface, from his book *Type, Sign, Symbol* (Zurich: ABC Verlag, 1980), 18.

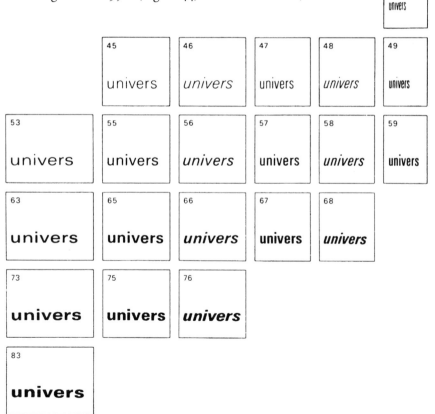

The 1960s and 1970s show two trends in general graphic and typographic design. One is the continuation of the searches initiated in the 1950s, and can be represented by the work of Frutiger (and his several fonts) until the design of the Roissy. He did this for the Charles de Gaulle Airport in Paris, and it became commercialized after 1977 under Frutiger's name (Figure 45). This kind of font was adopted enthusiastically by many designers of the 1950s and 1960s in search of a rational approach to communications with text, as the work of Josef Müller-Brockmann shows (Figure 46). A different trend is represented by a more organic, expressive, and free approach, such as the one developed in the 1960s in San Francisco (Figure 47). Letraset and ITC commercialized other fonts with these characteristics in the 1970s and 1980s (Figure 48) including the reappearance of geometry in typography, as shown in Herb Lubalin's Avant Garde, whose origin is based on Renner's Futura (Figure 49).

The two approaches mentioned above—one more functional, the other more expressive—have always coexisted in one way or another. The fundamental difference between them is that the development of the functional view allows one to speak about progress and working methods in the solution of certain problems, while in the more expressive approach one can only see an increasing quantity of available possibilities as time goes by. The field of font design has been dramatically facilitated and revitalized since the advent of digital fonts in the 1980s. Never in

continued on page 47

ABCDEFGHIJKLMNOPQRSTUV WXYZ 1234567890
abcdefghijklmnopqrstuvwxyz

45. Adrian Frutiger (1975), Roissy typeface, developed for the Charles de Gaulle Airport in Paris. Later on it was commercialized as Frutiger.

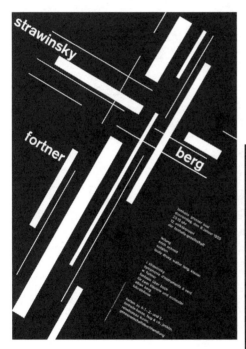

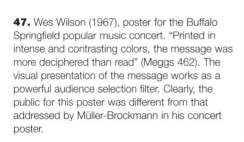

46. Josef Müller-Brockmann (1972), concert poster. (Reproduced by permission, © Shizuko Müller-Yoshikawa)

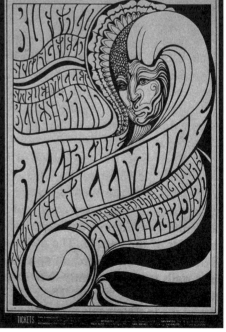

47. Wes Wilson (1967), poster for the Buffalo Springfield popular music concert. "Printed in intense and contrasting colors, the message was more deciphered than read" (Meggs 462). The visual presentation of the message works as a powerful audience selection filter. Clearly, the public for this poster was different from that addressed by Müller-Brockmann in his concert poster.

ITC Clearface Outline Shadow

ITC/LSC Condensed

ITC/LSC Condensed Italic

ITC Didi

ITC Eras Outline

ITC Eras Contour

ITC Fat Face

ITC Firenze

ITC Franklin Gothic Outline

ITC Franklin Gothic Outline Shadow

ITC Franklin Gothic Contour

ITC Gorilla

ITC Grizzly

ITC Grouch

ITC Honda

ITC Kabel Outline

ITC Kabel Contour

ITC Korinna Bold Outline

ITC MACHINE

ITC MACHINE BOLD

ITC/LSC Manhattan

ITC Milano Roman

ITC NEON

ITC PIONEER

ITC Ronda Light

ITC Ronda

ITC Ronda Bold

ITC Serif Gothic Bold Outline

ITC/L&C Stymie Hairline

ITC Tom's Roman

ITC Upright Regular

ITC Upright Neon

48. Fonts for titles by the International Typeface Corporation. These first appeared in *U&lc* 8, no. 1 (March 1981): 37A.

ABCDEFGHIJKLMNOPQRSTUVWXYZ
abcdefghijklmnopqrstuvwxyz
1234567890

history have we had so much to choose from; many new fonts are being created constantly.

49. Herb Lubalin: Avant Garde Medium.

The proliferation of fonts is not good or bad in itself. It is necessary, however, for designers to choose the appropriate language according to the purpose of the message and the public to be reached, instead of trying every novelty and attempting to express themselves.

Within the functional tradition, and following the results of related research about legibility and efficiency, Frutiger developed the font that carries his own name. This font, initially conceived for signage, surpasses the legibility performance of Helvetica and Univers on the basis of opening some typographic forms. We can see examples of this especially in some uppercase letters: *C*, *G*, and *S*; in some lowercase letters: *a*, *c*, *e*, and *s*; and also in numbers: 2, 3, 5, 6, and 9. The uppercase *Q*, however, has lost legibility due to a greater similarity to *O* (Figure 50).

The shape of each letter is, in general, more open in Frutiger than in Helvetica or Univers, and there is also more difference between letters. Another notable trend in new fonts conceived for signage is the narrowing of

CGSQ

CGSQ

aces

aces

23569

23569

50. (*above*) Formal comparisons between Helvetica (top) and Frutiger (bottom). The more open endings of Frutiger permit better legibility under poor visibility conditions, low light, and distance or narrow visual angle.

51. (*right*) Some areas of work, such as signage, benefit from narrow typefaces, as long as they permit good legibility from a distance. Comparison of width among several fonts of the same point size: Helvetica, Frutiger, Gill Sans, News Gothic, Syntax, Meta.

Hamburg
Helvetica

Hamburg
Frutiger

Hamburg
Gill Sans

Hamburg
News Gothic

Hamburg
Syntax

Hamburg
Meta

letters, which allows more characters per line without reducing legibility, a clear advantage for signage projects (Figure 51).

New production technologies have generated a proliferation of type fonts. Aside from those more subjected to fads and fashions, a recent example of an extremely efficient font designed with signage in mind is Meta, by Eric Spiekermann. Matthew Carter is also responsible for extremely successful fonts, including the redesign of Times New Roman for the *New York Times*. For publication design, one of the most efficient typefaces developed recently, particularly for use in small sizes, is FontanaND, published recently by Neufville Digital and designed by Rubén Fontana (Figures 52–57).

52. (*top*) Erik Spiekermann, Officina Sans.

53. (*bottom*) Erik Spiekermann, Meta.

ABCDEFGHIJKLMNOPQRSTUVWXYZ
abcdefghijklmnopqrstuvwxyz
1234567890

ABCDEFGHIJKLMNOPQRSTUVWXYZ
abcdefghijklmnopqrstuvwxyz
1234567890

ABCDEFGHIJKLMNOPQRSTUVWXYZ
abcdefghijklmnopqrstuvwxyz
1234567890

54. Matthew Carter, Galliard.

ABCDEFGHIJKLMNOPQRSTUVWXYZ
abcdefghijklmnopqrstuvwxyz
1234567890

55. Matthew Carter, Verdana.

ABCDEFGHIJKLMNOPQRSTUVWXYZ
abcdefghijklmnopqrstuvwxyz
1234567890

56. Rubén Fontana, Fontana ND.

ABCDEFGHIJKLMNOPQRSTUVWXYZ
abcdefghijklmnopqrstuvwxyz
1234567890

57. Sumner Stone, Stone Sans.

The historic evolution of alphabet design since the Renaissance shows five basic phases:

❶ *Roman tradition* from the sixteenth to the eighteenth century (Figures 34, 54, and 58).

❷ *Proliferation of drawn alphabets for headings*, to be used mainly in posters but also in magazines throughout the nineteenth century (Figures 5–13 and 59–63).

❸ *Geometric simplicity* of the 1920s (Figures 35, 49, and 64–67).

58. Frederic W. Goudy (1911), Forum.

continued on page 55

BEAUTY
IS THE VISIBLE
EXPRESSION
OF MAN'S
PLEASURE IN
LABOR
C D G J K Q
W Z &

FIG. 11 'FORUM' CAPITALS BY F.W.G. [1911]

59. Examples of typography for posters; mid-nineteenth century.

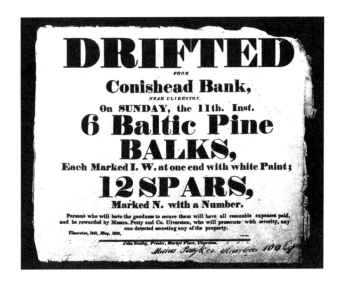

60. John Soulby Jr. (1833), poster. Ulverston: Museum of English Rural Life, University of Reading, England.

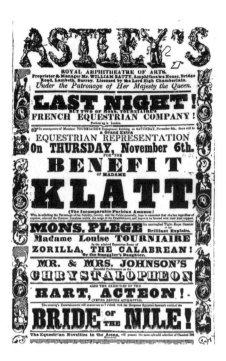

61. Klatt Benefit (1845), poster for the Astley Circus. Enthoven Collection, Victoria & Albert Museum, London, England.

62. A. A. Turbayne, *The Studio* magazine, special Winter 1899–1900 issue, p. 18.

Kronstadt 43

Ostende Hannover

Rochefort 53

Moskau Berlin

Nordhausen 34

Rotenburg Bregenz

63. Examples of calligraphic alphabets from the Roman Scherer catalogue, Luzern.

64. Georg Mayer-Marton (1929), geometric typography, Vienna.

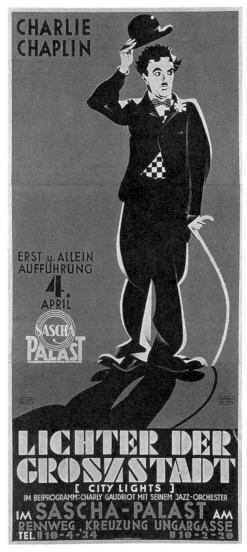

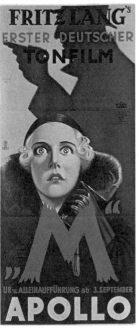

65. F. Adametz (1931), *Charlie Chaplin*, geometric typography, Vienna.

66. R. Vogl (1931), *Apollo*, geometric typography, Vienna.

❹ *Functional conception* in search for legibility in the 1950s (Figures 32 and 33).

❺ *New eclecticism*, allowed by the newer and cheaper technologies for typographic production and composition. This was first due to photo-composition and transfer lettering in the 1960s and 1970s (Figure 48), and then to digital technologies since the 1980s (Figures 52–57).

67. Anonymous (1920s or 1930s), *Sun Tan,* geometric typography, Canada.

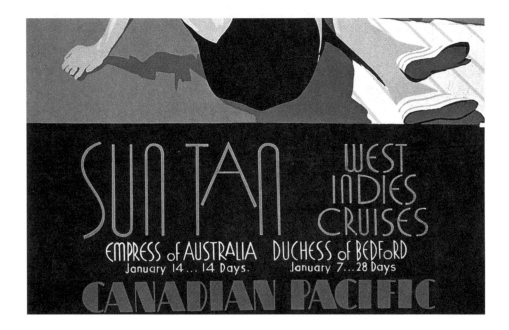

Design Principles: Functional Requirements

VISUAL COMMUNICATION DESIGN, AS WE KNOW it today, developed its essential components in the 1920s. It changed in the 1950s when new developments in psychology, sociology, linguistics, and marketing attracted the attention of designers, leading them to change their objective from artistic creation to effective communication. We are now witnessing a third stage, primarily based on developments in technology, which have resulted in increased attention paid to notions of interaction between the public and information.

The change that took place between the 1920s and the 1950s goes from an emphasis on aesthetics to one on communication. This change, of course, does not happen throughout the field, but only in the more advanced advertising agencies and design studios. Mass production of communication design in the 1920s was as far from the avant-garde as the mass production of the 1950s was from the pioneers of that time. Even

though A. M. Cassandre was already using simplicity of form in the 1930s that clearly related to Müller-Brockmann's work of the 1950s (Figures 68 and 69), there were designers who, in the 1960s, still produced work with a strong emphasis on visual sophistication, but that the general public found difficult to interpret. In those cases, the notion of formal innovation overpowered the need to communicate.

Perception and Meaning

Every design that competes with other visual stimuli (a poster in the streets, an ad in a magazine, a sign in a train station) must both attract and retain the attention of the viewer. To meet the first condition, the image must be strong enough to emerge clearly from its context. This is done through elements of form and content. The image must be visually strong, that is, it should have a high internal cohesion, and should at the same time differ from the context surrounding it. In addition, the content has to be relevant to the interests of the viewer.

This last aspect, which at first seems to be connected only to withholding attention, also plays a significant role in attracting attention. Looking is not a passive act. We do not look in order to see; we look to understand, and to find what we want. Signification and relevance are major determinants for calling attention. In legibility experiments, it has been found that words with negative connotations, such as "war"

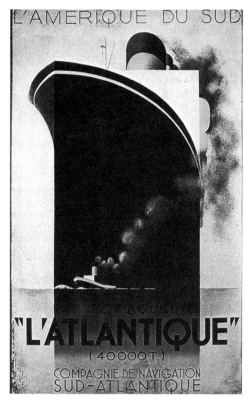

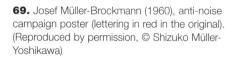

68. A. M. Cassandre (1931), *L'Atlantique*, poster for ocean liner.

69. Josef Müller-Brockmann (1960), anti-noise campaign poster (lettering in red in the original). (Reproduced by permission, © Shizuko Müller-Yoshikawa)

or "death," while having the same level of complexity as positive words, normally require more time to be read. It is as if there was a pre-perceptual ability to understand the words and to raise or lower the reading thresholds, possibly trying to preserve emotional balance. Similarly, content and aesthetics might affect the performance of a message: "In a crowded or competitive market, acceptance or rejection is often a split second decision . . ."(McConnell 131).

Given the number of "attention calls" we receive constantly in a city, it is easy to understand that we make a strong selection of the surrounding stimuli, processing only a small amount of the information present in our environment. This supports the need to communicate the content of a message through its most immediately visible elements. A poster with a general look that is not connected to its content will most likely be missed by the target public, while other groups interested in the visual structure of the poster —but not in its subject—might be the only ones paying attention to it.

Nevertheless, it is only fair to recognize the importance of the contribution made by artists and designers of the 1920s and 1930s to visual design in relation to the conception of visual attraction. Their explorations produced a revolution in their time and changed the spectrum of preoccupations of the visual communication designer.

These purely visual explorations are indispensable today as much in connection with the education of

designers as with the practice of design. But visual excellence is not all. Design should not only aspire to show visual strength and aesthetic excellence but also to use those dimensions in support of the communicational function. Communication, in turn, does not end with attracting attention. Essentially, it involves making information understandable, usable, interesting, and, if possible, pleasing. In addition, communication should generate the expected reaction from the public.

Beyond attracting and retaining attention, the designer should be able to address the following issues, which can be grouped into three major areas:

❶ Clarity of form and content (perception and understanding) in:

- The presentation of individual elements such as: letters, numbers, pictograms, diagrams, maps, charts, graphs, signs, symbols, signage, or control panels

- The organization of communicational sequences, including categorization of complex information such as: announcements, timetables, study programs, learning aids, legal documents, rules and regulations, theater tickets, emergency instructions, instruction manuals, Web sites, or user interfaces

❷ Facilitation and stimulation of reading (publication design)

❸ Consideration of cultural, social, economic, technological, and ecological aspects of all projects

Language and Signification

Today, designers have at their disposal the immense collection of visual resources that has been generated by a long tradition of art and design. The problem for the designer now is to avoid capricious selections and to develop a visual language that meets the needs of the project. This is one of the first challenges in the design process for visual communications.

The designer should develop a checklist to bear in mind for all projects, adapting and extending that list according to the requirements of each case. The general list could be as follows:

- Fitness to content (Is there a good relationship between the topic and the visual presentation?)

- Fitness to context (Are the visual language and structure appropriate for the people addressed and the situation in which the message will appear?)

- Quality of concept (Is there an idea or only a layout?)

- Quality of form (Is there a good perceptual organization?)

- Legibility/visibility (Are letters and images appropriately readable?)

- Craft (Is the project well presented?)

- Quality of medium (Are the possibilities of the medium well used? Is it the appropriate medium for the project? Are technologies and materials well used?)

In many cases, it will be necessary to add:

- Quality of the research (Is the information collected sufficient, interesting, and accurate?)

- Power of the persuasive arguments (What is the perceived advantage for the public to remember the information provided or to adopt a new behavior?)

Communication

An essential aspect of the designer's job is to constantly attend to a wide variety of diverse but interrelated problem levels. These levels can be organized according to five categories: communication, form, economics, technology, and management.

Communication is the reason for the existence of visual communication design, and represents the origin and the objective of all work in the field.

All perception involves a search for meaning, and it is, in this sense, a communicational act or a search for communication. The biological function of visual perception is to provide information about the surrounding environment to secure survival. Perception in general, and visual perception in particular, has not been developed to allow us to enjoy the beauty of the surroundings but to help us understand them; in other words, to interpret the data provided by the senses so as to build meaning. Perception, therefore, is connected to the most basic of the animal instincts: survival. Keeping this in mind, and considering that humans are fundamentally visual, it is easy to understand why visual messages can be so strong, even when their content could be trivial; it is the channel that gives them strength.

The Gestalt psychologists went beyond previous theories when they proposed perception as a structural process, different from the sequential and additive character of previous descriptions. Their attention was directed to formal issues related to the organization of the images, leaving matters of meaning out of the picture. The study of the organizational principles of human perception is important, but it is necessary to see these principles as strategies used in a search for meaning, and not just as automatic organization processes devoid of other purposes.

We could recognize two fundamental components in any perception: the search for meaning, and the construction of meaning based on the organization of the stimuli. Essentially, this organization is carried out

on the basis of principles of integration and segregation that connect and separate elements through proximity, similarity, and closure (good form)—the basic laws established by the Gestalt school.

In addition to the processes of organization discussed by the Gestalt school, it is worth remembering that the signifying function is an essential and immediate aspect of the perceptual process. It could be sometimes more rational and conscious, and sometimes more emotional and automatic, but it is always present. Difficulties with this function generate emotional tension, anxiety, fear, fatigue, or boredom, according to the circumstances.

Every shape evokes a response—more or less cognitive, more or less emotional. This demonstrates the importance of designers in the organization of the perceptual, emotional, and cognitive processes to be followed by the viewer, beyond purely aesthetic issues. It would be a fundamental error to believe that in design one can deal with form independent of content, or with the sensorial, independent of the cognitive and the emotional (Sinclair et al. 178).

In some cases, the organization of the elements might not have a cognitive function, beyond that of making the information accessible, as in the case of timetables, catalogs, programs, and other examples of visual presentation of information. Design, however, is never neutral, despite what was believed by the Swiss modernists in the 1950s and 1960s. Every form, in addition to its fitness for the informational job, has a

cultural root and a cultural impact; it promotes certain values and pertains to a given social class, and many times to a specific race or gender. Neutral design does not exist (Frascara 119).

As previously stated, perception implies a search for meaning and the organization of stimuli in a signifying array. This is a process of interpretation. To perceive is not to receive information passively. To perceive involves searching, selecting, relating, organizing, establishing connections, remembering, identifying, defining hierarchies, judging, learning, and interpreting. The more organized the stimuli are in relation to the public's cognitive style, the easier it is to interpret them. This is why it is so important to use pertinent symbols in graphic messages, and to organize them according to systems that are understandable by the public.

Designers such as Tschichold or Müller-Brockmann concentrate on the communicational function of their visual compositions; this explains the inclusion of these designers in the history of the profession. The simplicity of their designs is based on criteria for the selection of content-carrying components, and a dedication to the logical and aesthetic organization of those components so as to arrive at the highest possible effectiveness for the message. Their works, however, cannot be taken today as paradigms, because during their work-life it was not known that different audiences require different logics, and, in general, different ways of presenting information that call for a more context-sensitive approach to designing.

The selection of the components of a message determines to a great extent the semantic content of the message. The organization of those components can reinforce the meaning of the message. This organization is centered on syntactic issues; that is, on the ways in which the components can be presented so as to facilitate the processing and understanding of the message by the public.

Followers of Tschichold, Müller-Brockmann, and the Swiss school in general, did not realize that every visual style expresses a value system—or in other words, has a content. It is not possible to design neutral typography or neutral layouts. Any layout will better support some messages and work against others. "Walking down a country lane you see a sign saying 'Fresh eggs.' A simple enough message, but the fact that it is hand-written on a broken piece of board actually makes the freshness of the eggs more believable, even though you do not consciously acknowledge it. But if you then go further along the road and see a similarly hand-written sign saying 'Flying lessons,' the effect is exactly the opposite" (McConnell 131).

The visual organization of a message, therefore, must be appropriate for its contents. The visual organization of a design serves to establish clear relations of importance, inclusion, connection, and dependence, and serves to guide the sequence in the perception of a message, helping the viewer in the process of constructing meaning. Given that the effectiveness of a message hinges on its interpretation by the public, the evaluation of a design has to be based on

measuring comprehension by the intended audience, and not on aesthetic preference measured by experts.

Every design strategy should be conceived as a working hypothesis that might require experimental testing to become trustworthy, even though it could be based on extensive experience. Semiotics, rhetoric, and perception theory on the one hand, and marketing, social psychology, and learning theories on the other, provide a good start. But these areas of knowledge cannot guarantee the performance of a new design. In every complex project, it is necessary to go beyond the application of existing knowledge to study the specific conditions of the project at hand. This, little by little, continues to develop knowledge in the field and helps to plan communications on increasingly proven principles.

To sum up, a series of principles can be extracted from the preceding discussion:

- Every visual element conveys meaning

- Every layout conveys meaning

- Every meaning presupposes an organization

- Every organization is based on principles of integration and segregation

- The principles of integration and segregation are based on the Gestalt principles of similarity, proximity, and good form

- Every visual message involves form and meaning

- The meaning of a message requires a process of interpretation

- Every message is produced to generate an action of some kind

Meaning and Interpretation

The interpretation of a message involves two levels: denotation and connotation. Denotation refers to the relatively objective dimensions of a message, such as descriptions or representations in images or texts. Connotation refers to more subjective aspects of a message, and it is particularly important when the message strives for an emotional appeal, as in the case of persuasive messages. At the level of connotation, the public participates more actively in the construction of meaning. The connoted message is more culture-dependent, and it is built as a combination of the designer's concept and the target public's experience.

For example, a seventeenth-century Dutch painting of a platter of fruit is a platter of fruit for us and for most people; this is the denoted message. The connoted messages, by contrast, may vary from person to person, or from group to group. For some people the painting may mean abundance; for others hedonism; for others it is a painting of good or not-so-good quality; and for still others it is a painting without imagination, or the symbol of a materialistic society. For everybody, however, it is a platter of fruit.

Although images are more likely than texts to elicit a great variety of connoted messages, this is also possible for texts, depending either on their style or content. A text could be boring for a sophisticated audience but engaging for a more naïve one, or the other way around. What could appear as interesting engineering knowledge for the layperson might sound like a pack of lies to an engineer. The text that sounds pompous to some readers might command respect from others. It is, therefore, essential to make every effort to understand the cognitive and cultural profile of the target audience. This applies as much to the content as to the form of both images and texts. In the process of crafting a message, it is always advisable to test it with a sample of the intended audience for comprehensibility and general reactions. It is difficult to craft the best possible message on existing knowledge alone.

The control of the denoted message is simpler. It is necessary, nevertheless, to avoid the trap of using oneself as the sole referent in determining whether something is clearly denotative. Different ways of thinking and different contexts can separate the world of the designer from that of the audience and generate a communication breakdown if the public's cognitive culture is not known to the designer. Some conventions that appear obvious to us—such as reading a cartoon from left to right, or interpreting the floor plan of a building or a section of the earth's crust—might create total confusion in the person who does not share those conventions with us (Figure 70).

A clear example of the inability of designers to properly assess the clarity of a message comes from work done by the International Standards Organization on the comprehension of graphic symbols for public information. These symbols, which should be understood by people from many different cultures, normally perform much below the designers' expectations (Easterby and Zwaga; Easterby and Graydon).

Beyond the ability of the public to understand an intended meaning, every message generates an emotional response that is consciously or unconsciously experienced by the public. This predisposes people to accept or reject, to forget or remember, or to obey or dismiss the purpose of a message.

The final message—that is, the interpretation built by the public—is a cognitive/emotional/operational unit that can only be divided for the purpose of studying it. The experience of the people exposed to the messages is holistic, and can only be predicted within a generous margin of uncertainty. Hence the

70. "Because many South African mine-workers are unable to read, this cartoon was devised to persuade them to leave the rails free of stones. However, it did not work—increasing numbers of stones were found on the rails. The cause, it was discovered, was that the miners tended to read the message from right to left, and so they helpfully complied and took the stones out of the wagons!" Unger Mijksenaar, "Signposting and Communication Media," *Icographic* 7 (1974): 19.

need to engage in testing, particularly when the communication project attempts something unusual, something that goes against current habits, or something that intends to change them.

Contexts

The context for a message requires special attention. The concept of "context" is applicable at several levels, but fundamentally encompasses the ones listed below:

- *Perceptual*: the visual environment in which the message appears

- *Cultural*: the cultural environment of the target audience, their values, their habits, their codes, and their attitudes

- *Source*: the collection of messages already issued by the same person or organization

- *Source's class*: the cluster of messages created by similar organizations, such as educational, commercial, or governmental sources

- *Aesthetic*: formal qualities that position the message within a given approach, such as contemporary, traditional, popular, or other recognized visual styles

- *Media*: the environment created by the medium used; for example, newspapers, TV, books, magazines for women, the World Wide Web, etc.

(at a finer level of detail, it could be a particular magazine, a particular TV program, etc.)

- *Technical quality*: the level of technical expectations of the target audience in the particular medium used

- *Language*: the environment created by the usual written and spoken language in a given place by a given group

All these contexts affect the message and the processes of interpretation. If we understand the communication process as an act in which the public builds a meaning, we realize that the graphic message by itself is incomplete. It remains relatively uncertain until a person completes it through an act not of reception, but of interpretation. This is a complex act, involving cognitive and emotional responses, and one in which people develop a relationship not only with the message but also with the source.

Every communication in design involves a source, a designer, a medium, a code, a form, a content, a context, and a public (that builds a meaning, develops an attitude, and adopts a visible or internal behavior). Every communication involves perceptual, emotional, and cognitive processes (denotative and connotative). Form and style always communicate. Every communication is affected by the different contexts that surround it.

Aesthetics

There are several reasons why aesthetics is a major concern in design:

- It creates attraction or rejection "at first sight"

- It communicates

- It affects the perceptual time an onlooker dedicates to a design

- It affects the memorization of the message

- It affects the active life of the design

- It affects, in a broad sense, the quality of the environment

Attention and a good disposition on the part of the observer are necessary for communication to take place. The attention of the observer must be secured not only through the loudness of the stimulus or the relevance of the content but also, and fundamentally, through the positive attraction that the stimulus generates. Stimulus strength is necessary, but excessive loudness can create negative effects. The name of an old advertising agency, "A Punch in the Eye," belongs to a time in which it was believed that the function of the advertising designer was to capture the audience's attention at all cost, without taking note of the negative effects that a "noisy" image can have on a product.

My defense of the importance of aesthetics does not relate to the notion of good taste. It is important to understand the audience that the communication is intended to reach. There should be a fit between public, product, and message in which the aesthetic dimension is of great importance. This is clearly apparent in the advertisements designed for Knoll by Herbert Matter and for Hermann Miller by Armin Hofmann. Their aesthetic conceptions not only were in line with those of their clients, they certainly contributed to the development of those firms' corporate identities (Figures 71 and 72).

The emotional reaction a segment of the public will have to a product is heavily affected by the aesthetics

71. (*left*) Herbert Matter (1956), *Knoll*, magazine advertisement. (Reproduced by permission, Knoll Inc.)

72. (*right*) Armin Hofmann (1962), magazine advertisement for Hermann Miller.

of the communications that present the product. Some people might find the ads by Matter and Hofmann cold and pretentious, and would feel more attracted to what one sees every day in newspapers (Figure 73).

An aesthetic choice is a judgment call. There are no universally agreed-upon principles of beauty and ugliness. One's choices are culturally constructed and represent value systems. In communication design, the languages of the target population being addressed must be understood. One's own personal preferences have to be harmonized with the needs of the project if one wishes to feel a personal satisfaction and wants to produce effective communications.

Aesthetics and Communication

Every aesthetic choice carries meaning. It is not possible to improve or worsen the aesthetic quality of a message without altering its meaning, increasing or reducing the strength of the message, or having an effect on the segment of the public being selected by the message.

At the University of Alberta, during building renovations, one of the access doors was closed to the public for a few days. A worker put up a sign: "Use the other door." Because the message was written informally, on a piece of torn paper, it worked perfectly. The temporary character of the sign clearly expressed the temporary character of the problem. The shape of the paper made it highly conspicuous against the geometric character of the building. The poorly drawn letters contrasted with the Helvetica Medium of the building's signs. The small sign, in its totality, expressed the presence of the workers. Had the sign been prepared according to the signage manual for the building, it would have been more in accordance with the aesthetics of the whole place, but it would not have worked so well, allowing people to find themselves wrestling with an unopenable door without having noticed the sign. The same can be said of frequent but temporary "out of order" signs on vending machines (Figure 74).

If permanent signs had been installed with the lack of aesthetic concern of this sample, the visual quality of the environment would have suffered dramatically.

74. A case of communicational efficiency for a short-lasting message. The sign clearly expresses the double message: "out of order" and "temporarily." It is located in the right place.

But the worker's sign, given its purpose and its useful life, could be defined as an excellent design, including maximum communication with minimum size and resources. When the Department of Art and Design was running a three-day event, the announcement had to be really large, so as to call attention while maintaining the dominant aesthetics of signs in the building. Size, in this case, had to be extreme, in order to make the sign visible.

The aesthetic evaluation of quality must be attempted, bearing in mind fitness to purpose, content, context, and public. The aesthetic quality of a painting by Matisse is not questionable, so a poster by him will normally be accepted as having a high aesthetic value (Figure 75).

But the style would not be appropriate to support Olivetti, whose image of precision, elegance, and simplicity was successfully developed in the 1950s by Giovanni Pintori (Figure 76). In turn, Pintori would not have been the ideal designer to promote the Moulin Rouge (Figure 77).

Three posters by Yusaku Kamekura for the 1964 Olympic Games in Tokyo give us a feeling for the perception of sports at the time. Fascinated by the new advancements in photography, and its capacity to freeze movement, Kamekura gathered all the electronic flashes he could get hold of and shot the pictures on the left and right. The central image, dwelling on a traditional Japanese minimalism and the Japanese flag, represents the logo of those games (Figure 78).

When Otl Aicher designed the posters for the 1972 games in Munich, he took quite a different approach: the posters are closer to being abstract paintings, and color became a central element in the identity of those games (Figure 79). In the 1960s several leading designers saw the advantages of offset printing, and played with the new possibilities of the medium,

continued on page 82

75. Henri Matisse (1973), *Henri Matisse, Acquavella Galleries,* poster. (Reproduced by permission, © Acquavella Galleries Inc.)

76. Giovanni Pintori (1947), *Olivetti*, poster. (Reproduced by permission, © Archivio Storico Olivetti, Ivrea, Italy.)

77. Henri de Toulouse-Lautrec (1893), *Jane Avril*, poster.

78. (*above*) Yusaku Kamekura (1964), three posters for the 1964 Tokyo Olympic Games. (Reproduced by permission, © Kan Mizukami)

79. (*left*) Otl Aicher (1972), poster for the 1972 Munich Olympic Games. (Reproduced by permission, © Florian Aicher)

resorting to transparencies and distortions that extended the vocabulary of the communication designer at the time, while trying to call attention on the basis of visual innovation. Victor Moscoso, by contrast, used visual resources to position his work as pertaining to the youth of his era (Figure 80).

His design was meant to slow down reading, so that the busy businessperson in a hurry could not read it—and be somewhat outraged by it. Yet, when Distéfano, Fontana, and Soler created a poster for a show of Olivetti products, they used a style related to optical art, but aimed at the segment of the general public that could be interested in the exhibition being promoted (Figure 81). As another example of fitness to content, Susan Colberg designed a book cover in 1996 using an archival photograph of filmmaker Jean-Luc Godard at work, rendered in a grainy texture, to suggest the character of black and white film (Figure 82).

Her cover for *A Guide to Heidegger's Being and Time* uses a leaf to symbolize the importance of the transitory in Heidegger's philosophy (Figure 83). Whereas Colberg's covers for SUNY (State University of New York) Press are characterized by subtlety, contemporary visual language in editorial design can be quite "in your face," as can be seen in many general interest magazines, particularly those for the young. The culture of technology also has its own aesthetic principles. The cover design by Dynamic Diagrams comes from an aesthetic related to the new electronic media (Figure 84). *continued on page 85*

80. Victor Moscoso (1967), concert poster.

81. Juan C. Distéfano, Rubén Fontana, and Carlos Soler (1967), *Olivetti*, exhibition poster. (Reproduced by permission, © Juan C. Distéfano, Rubén Fontana)

82. Susan Colberg (1996), *Godard*, book cover, SUNY Press. (Reproduced by permission, © Susan Colberg)

83. Susan Colberg (2000), *A Guide to Heidegger's Being and Time* book cover, SUNY Press. (Reproduced by permission, © Susan Colberg)

84. Dynamic Diagrams (1990s), *From Memex to Hypertext*, book cover, Johns Hopkins University Press. (Reproduced by permission, © Krzysztof Lenk)

Not only must the aesthetic approach used in a message be appropriate for the target audience, but the designer should also control the meanings that the forms convey to that audience as well. A style that can express precision for some could be cold for others: expressiveness may appear as chaos, order may be seen as rigidity, disorder as energy, and energy as violence. Without a good understanding of the codes of the target audience, the fashioning of a message can easily miss the target. Fundamentally, before evaluating the aesthetic quality of a message, one has to ascertain whether or not the approach adopted is coherent to the public and the message in question.

Extending the Perceptual Time

In the usual environments in which visual chaos and ugliness tend to dominate, visual pleasure has an important role to play in the retention of the viewer's attention. It is not necessarily the case that the image capable of attracting the attention of a given group will also be capable of retaining it. The public's preferred aesthetic style might not be appropriate for the product in question. To attract, to retain, and to communicate are three essential functions of every message, and aesthetics plays an important role in all three of them, but it should never become a distraction.

Memorization

Given the discussed conditions, a message that attracts attention, communicates without contradictions, and

retains attention on the basis of pleasure through a sustained time will obviously be more memorable than a less attractive, more incoherent, less pleasurable, and more fleeting message. But the purpose of a message is not just to be remembered by the public. It is most important to verify if, beyond remembering it, the public has developed the changes in knowledge, attitudes, or behavior that the message was intending to generate. It is also necessary to verify what it is that the public remembers. In his famous book, *Ogilvy on Advertising,* David Ogilvy warned against the use of celebrities for advertising, since, according to his research, people tend to remember the celebrity but not the products advertised (109).

Although the subject of this section is aesthetics, it is necessary to remember that the memorization of a message is connected to several factors. A message that indicates that it is forbidden to dispose of garbage by the roadside, for instance, will be better remembered if the fine is expensive than if it is cheap, particularly if there is a perception of enforcement. It is not possible to understand the role of aesthetics without a context. It is not possible either to understand the function, the limitations, and the possibilities of design without putting this in the social, political, physical, cultural, and commercial contexts in which it operates.

Active Life of a Design

A design with a high aesthetic value will have more chance of being kept active in the mind of its public. Even after its function as an announcement for a

show has passed—or any other passing event—
printed materials, such as posters, maps, graphs,
calendars, and advertisements of high aesthetic value
keep on showing up in exhibitions and publications
and continue to issue their message. True, the
message they issue is not the same as the one that
generated them, but it is one that contributes
positively to the image of those who generated it. In
some cases, such as the designs Cassandre did for
Dubonnet in the 1930s, the original design was used
for many years (Figure 85).

The Quality of the Environment

The quality of the environment is one of the social
responsibilities of the designer. Our urban life is
surrounded by design: architectural, industrial, and
graphic. A painting might begin its life in a studio, be
shown in a gallery, and end up in someone's house.
The cover of a book, alternatively, printed five
thousand times, shown in dozens of shop windows,
placed on top of five thousand tables in five thousand

85. A. M. Cassandre
(1932), *Dubonnet*,
advertisement.

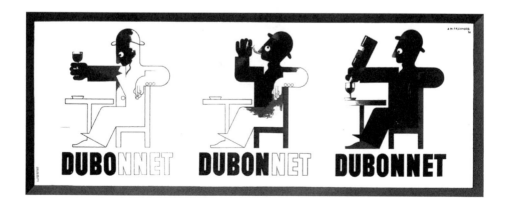

houses, reproduced in hundreds of thousands of newspapers, on thousands of leaflets, and hundreds of posters has a presence that, although somewhat fleeting, strongly affects our daily environment. This is why communication design quality should be considered not only in connection with the specific scope of the project in question but also with regard to the cultural impact that it has on our daily life.

In order to understand the requirements of a project, designers must ask themselves a number of questions:

- What is the purpose of the message?

- What is the content of the message?

- What are the implied messages and their relative importance?

- Who is at the origin of the message?

- What is the profile of the target audience?

- What is the budget?

- What are the media to be used?

- In which contexts will the message be issued?

There could be more questions, depending on the project. This is just an idea of the essential territories that have to be covered by any design project.

According to the responses to these questions, the designer plans the message at many levels: form, code, language, purpose, narrative, and media. The process involves technological, logistical, and financial decisions, and ends up with an evaluation plan aimed both at measuring the success of the communicative action and at collecting feedback to improve that action.

Methods and Planning

EVERY COMMUNICATION DESIGN PROJECT, to a greater or lesser extent, requires planning at the levels of communication, visualization, and production. The first two levels imply study of the problem, development of strategies, and creation of design proposals. Production requires organization of resources (human, technological, and economic) and final fabrication.

The development of a list of requirements and their relative importance is one of the first steps taken during the study of the problem. In this way, the designer maps the tensions between the requirements and is able to take positions regarding priorities. These priorities are not necessarily lists with a clear hierarchy, because design is characterized by the interdependence of factors. "We know that we shall never find requirements which are totally independent. If we could, we could satisfy them one after the other, without ever running into conflicts. The very problem

of design springs from the fact that this is not possible because of the field character of the form-context interaction" (Alexander 213).

The designer also coordinates the project in connection with due dates, and plans the sequence of steps of the project. This timeline allows the designer to assess the cost of the project, to control its realization, and eventually to evaluate whether the projected timeline was accurate or unrealistic. Although it seems obvious, it is important to state it: to plan, including timeline planning, develops one's ability to plan. Without an articulated intention, it becomes very difficult to develop one's own abilities to estimate the time and resources required by a job. Planning allows one to compare estimates to actual outcomes, and sharpens one's ability to get ready for the needs of a project before they show up.

In addition to this organizational task, the designer considers space and time as they affect the final product: space, with regard to the physical and visual composition of the design product; time, concerning the way in which the visual product is captured by the public during its interaction with the message. The sequence of this interaction is a central issue in connection with the potential effectiveness of a communication.

From a different point of view, during the development of the project, the designer must be concerned with the management of space in the office, and access to information, materials, and people, in

order to maximize the efficiency of the task. The organization of the design process is a design problem.

Design Methods

The 1960s saw a strong development in design methods. There was an increase of literature on methods at that time, written by engineers, architects, and industrial designers. Some of those methods, in whole or in part, can be applied to communication design. The authors, however, normally recommend caution in their implementation, noting the importance of specific details in particular situations for any design project. Methods, more than a mechanical technique, are strategic aids directed at proposing routines that help to resolve a variety of problems. They are directed at reducing the time invested in the design process, and, in general, at rendering it more efficient and effective. They are not prefabricated solutions.

Nigel Cross and Robin Roy describe fifteen methods in their *Design Methods Manual,* and all, in one way or another, are relevant to visual communication design. These methods, however, are somewhat abstract, and it is advisable always to anchor them in the context of the specific situation a design project confronts.

It is as difficult to solve a design problem by first identifying all the elements and variables implied as it is to do it without trying to identify them. An integrated

method, in which abstract processes and tentative visualizations alternate, seems to be the most intelligent approach to working in visual communication design. The search for a solution should be systematic and exhaustive, but the steps in that search must involve a variety of ways of analyzing and formulating the problem. Normally, these ways include non-rational strategies and tentative visualizations at the initial stages when one does not yet have sufficient information to develop final visualizations. At this stage, visualizing is another way of studying conditions and possibilities leading to the solution of the problem. To facilitate this process, it is indispensable at the outset to define not how the design must look, but what the design must do (Cross and Roy 19).

The information obtained about a project, although it can provide essential criteria for the configuration of the visualization, is never sufficient to generate a solution. There is always a need for a creative leap in the interpretation process, where the designer considers all the information collected, but does not just respond to it. Visualization is not a mechanical process that results exclusively from the information collected for the specific project. Other contexts have to be brought into play to produce a piece that not only does the job but also does it well, adding value to the experience of the public, and attending to cultural, personal, and experiential dimensions. This is why the visual communication designer should be not only a technician but also a visually sophisticated and well-educated person, with a high ability to obtain, organize, process, and present information.

The Design Process

Given the variety of situations that communication design deals with, it is not easy to establish a sequence of steps that can be applied to any visual communication design project. Some essential steps, however, can be identified. The sequence of the design process could be outlined as follows:

❶ *Commission of the project*: First definition of the problem and the budget

❷ *Collection of information*: About the client, the product, the competition (if it exists), and the public

❸ *Second definition of the problem*: Analysis, interpretation, and organization of the information collected

❹ *Definition of objectives*: What should the product do? Definitions of communication channels (how to get the product physically to the public), arguments (how to cognitively and affectively communicate with the public), form (how to perceptually and aesthetically reach to the public), as well as the preliminary study of implementation

❺ *Third definition of the problem*: Production specifications, putting the problem in design and production terms, and writing the design brief

❻ *Development of the design proposal*: Considerations of form, content, media, and technology

❼ *Presentation to the client*: An informational and persuasive act

❽ *Organization of production*: Preparation of the final design ready for production

❾ *Supervision of implementation*

❿ *Evaluation of performance*: Comparison of results with the established operational objectives, eventual adjustments based on the evaluation, and further adjusted implementation

A discussion of this summary might help to clarify some points.

Commission of the Project

The commission of the project involves the definition of the budget and the first definition of the problem. The client is the first person who attempts to define the problem—identifying a need or a wish, and an objective—and contacting a designer. Frequently, clients ask designers for a specific service, reducing their participation to that of visualizers or draftsmen. The designer needs to get the full picture from the client: the identified need, the essential objective to be achieved, and the full context. The task of the designer at this stage is to redefine the problem in design terms and

objectives, and in achievable and measurable ways. Metaphorically speaking, the client can say that he needs a bridge, when his need might be to cross a river. There are many ways to cross a river, and it is the task of the designer to compare the possible solutions, recommend the best ones, and eventually develop the most appropriate one.

Although the client initiates the process, the designer must reevaluate the situation and advise the client, sometimes against the client's initial assumptions, and sometimes to the detriment of the designer's short-term benefit. This is the case when one advises the client that, for a given situation, the best option is not to design a product. Some years ago, one of my clients asked me to design a brochure to communicate to his clients the offering of a new service. Given the required communication and the clients in question, I advised him to send a letter instead. In that case, a letter was, in my judgment, more credible and a better promotional tool than a brochure. I was not hired for the project, but I strengthened my relationship with the client.

At this stage, the political problem is that if the client's idea about the design solution does not work, the person to be blamed will be the designer. This is why the designer cannot use the client as the sole source of information about the problem. One has to become as informed as possible about the client's problem, not only using client input but also independently seeking relevant information. This applies to the budget as well, which is normally defined by the

client. In some cases, however, through the presentation of new information, the designer might persuade the client to change it.

Collection of Information

This stage aims at gathering information about the client, the product, the competition (if it exists), and the public. Here the designer places the project in context, starting from the definition of the client's organization through a description of its operations, its corporate image, and the integration of the project at hand within the organization's value system and sociocultural profile. It is also possible that the analysis of the project in question could suggest a need to modify certain aspects of the client's existing public image or business strategies (or educational, administrative, or whatever category might apply to the particular client). A broad set of possibilities opens up when one investigates in detail the contexts that surround a given design product.

Needless to say, the analysis of the product itself, particularly in advertising, is an essential element of this process. A corporate image cannot be developed by a designer who does not have an intimate knowledge of the client's organization; it should be comparable to what its president or manager has. A textbook cannot be designed without knowing its content; a consumer product cannot be promoted without information about the product, so as to develop convincing sales arguments.

David Ogilvy, a pioneer in contemporary advertising, stated in his book, *Ogilvy on Advertising*: "First, study the product you are going to advertise. The more you know about it the more likely you are to come up with a big idea for selling it. When I got the Rolls-Royce account, I spent three weeks reading about the car and came across a statement that 'at 60 miles an hour, the loudest noise comes from the electric clock.' This became the headline, and it was followed by 607 words of factual copy" (see page 34, figures 28 and 29). "Later," Ogilvy continues, "when I got the Mercedes account, I sent a team to the Daimler-Benz headquarters in Stuttgart. They spent three weeks taping interviews with the engineers. From this came a campaign of long, factual advertisements which increased Mercedes sales in the United States from 10,000 cars a year to 40,000" (Ogilvy 11).

This could be defined as content-driven communication design. When Jacqui McFarland set out to design a workbook for AutoCad for use by interior design students in Alberta, the success of her work came from her intimate knowledge of the program and her understanding of both teaching and visual communication design. Other publications produced to help people learn how to use computer programs normally lack knowledge of visual communications, and, although they show everything that a program can do, they do not show it in ways that the public can understand. Because she is a communication designer, an interior designer using AutoCad, and works in education, McFarland could deal with all aspects of the project at hand. Visual communication

design requires proficiency in both form and content. If the product is a learning aid, then knowledge and experience in education are indeed strong assets.

An important source of information for the designer is the public. To gain information from the public, the designer can use observations, focus groups, and interviews, for which there are sophisticated methods developed in anthropology, marketing, psychology, and sociology. The information obtained from the public to aid the initial development of the design can be complemented by additional information obtained after the production of prototypes. Usability tests allow a more accurate way to assess the reactions of the public. Participatory approaches have been developed recently whereby samples of potential users contribute to the design effort (Sanders 1).

Another element to consider is the analysis of similar products, including the competition, if it exists. A milk carton, a book, or an advertisement are all examples in which the analysis of the competition is essential. A sign system, a banknote, or a user's manual are samples in which one can analyze similar products, but where one cannot really talk about competition.

Analyses of the product, of similar products, of competing products, and of public reactions to them and to new proposals create a basic mapping for the task at hand. Experts in relevant fields and experienced colleagues can also provide useful observations.

Second Definition of the Problem

The information collected assists in the development of design criteria. This information must be compared with what the client provided to organize the process of analysis and interpretation. All the information collected forms a basis for the design process, but it does not dictate it. It leads to a second definition of the problem.

There are two basic issues to keep in mind when managing information: First, it is necessary to be clear about what one is actually measuring; and second, to remember that surveys indicate tendencies—that is, strengths and weaknesses—not the presence or absence of a concern. Public preferences are always expressed in levels of intensity that must be interpreted. Sometimes it is possible to test two alternative solutions and find that one is received much better than the other. In other cases, testing could be directed at discovering public trends and favored aspects of the products tested. This could lead to better proposals than any of those tested initially.

In a project developed some years ago for Parks Canada at the University of Alberta, two students measured the reactions of the public in front of four visualizations for a poster, in terms of stylistic preference and visual attraction. The test was carried out at a shopping center in Edmonton. To measure visual attraction, the posters were placed on the walls. The posters took on different visual approaches: one used bright colors and simple geometric forms,

another was photographic with full tonal range, a third one was based on a high-contrast photographic image, and the fourth one was hand-drawn. The experimenters counted the number of people who stopped to look at each poster. The one people looked at the most was the brightly colored poster of geometric shapes.

In the second testing, where people were asked to choose their preferred poster, the majority favored the photographic one with full tonal range, and sent the geometric one to last place. The experimenters were surprised initially at the apparent contradiction, but they soon realized that they were measuring two different things (Figures 86 and 87).

A situation of this kind frequently generates somewhat contradictory recommendations that get solved by looking at solutions of integration rather than at mutual exclusions. In this case, it was clear that to make the poster visible it had to have color and contrast. For it to be enjoyed, it had to use photographic images. The designer can take the two recommendations and produce something that is both attractive and pleasing, or can judge that such integration is not possible or advisable and favor one of the aspects, depending on the circumstances. This is why it is necessary to determine, from the outset, which is the most important dimension: Should it be seen or should it be enjoyed? If one decides that the posters must first and foremost be enjoyed, then other dimensions of implementation could be explored, such as size, placement, or lighting, to ensure that the

posters will be seen without needing to change the most-liked visual design.

It is always essential to keep in mind the main objective of a campaign. In this case, the idea was to promote parks that were not heavily visited to avoid overcrowding at a few popular parks. Initial testing can only provide some indicators. The final evaluation must be done after implementation, measuring, in this case, the actual number of people who go to the promoted parks, and assessing whether the objective of the campaign—a better distribution of park visitors—is actually achieved.

86 and 87. Jane Broadbent and Leila Nachtigall (1979), under art direction by Walter Jungkind, posters for Parks Canada. (Reproduced by permission, © Walter Jungkind)

A different kind of project, addressing special-needs users of parks, was developed by Bonnie Sadler Takach from the research she had begun to conduct when doing her master's studies in design at the University of Alberta. She developed an accessible interpretive exhibit for visually impaired people, incorporating a set of tactile symbols that were created and tested by her. Sometimes research serves to make choices between existing possibilities; sometimes it serves to invent new devices (Figures 88 and 89).

The analysis of individual aspects of the design is both possible and important in the information-generation process. It is equally important to consider the relations between those elements and the central objectives of the project, while carefully evaluating the information gathered so as to arrive at a good second definition of the problem. The analysis of individual aspects of the design serves to generate hypotheses about the final design product. However, the design is bound to proceed to the next step with a little uncertainty. It is impossible to predict precisely the response of the public to a given design solution. This is why performance evaluation is such an indispensable part of the design process. This is true not only for serial or repeated publications, such as textbooks and magazines, but also as a way to check one's ability to produce effective solutions based on artificial settings (such as those habitually used in market research tests) and partial measurements.

In the design development process, one has to measure a number of independent dimensions to

88 and 89. *Olive Lake tactile map*, Parks Canada, cast-bronze tactile map. Research-based design for visually impaired people. (1993) (Reproduced by permission, Copyright Parks Canada. Design by Bonnie Sadler Takach)

come up with an efficient whole in the end. In the process of evaluation, in addition to measuring overall performance, one must identify strong and weak components in the product's performance. Research on individual components may include performance measuring of detection, legibility, comprehension, pleasure, recall, and medium. The evaluation should identify possible improvements through the modification of those aspects deemed deficient.

Every detailed definition of a problem helps the designer get closer to its solution. The purpose of the discussion of the last pages is to avoid the temptation to jump into solutions before the problem can be clearly defined and described. Often the trust in intuition, the lack of discipline, the lack of research knowledge, the immaturity and impatience of the client or of the designer, and the belief in miraculous inspiration, lead to the design of products that suffer from inadequate analysis of the problems involved. In these cases, speed is mistaken for efficiency, and the evaluation of performance is ignored, foggy, or impossible to implement.

Definition of Objectives

The "definition of objectives" means understanding what the product should do: definition of the communication channels (how to get the product physically to the public); definition of the arguments (how to get the product cognitively and affectively to the public); and definition of the form (how to get the product perceptually and aesthetically to the public).

The projected implementation of the product is studied in this stage.

The general objective of the project is now redefined, somewhat modifying the initial statement of the client. In addition, subsidiary objectives are defined with a view toward ensuring the achievement of the main one. Here one defines what the product should do, and what it should be like, so that it achieves its purpose. This process includes the definition of media, implementation context, reach, and message. A new analysis of requirements and their interactions allows the implementation team to make final decisions.

Media choice is a key decision because it affects context, reach, and message. Every medium has a definable public, as much in number as in profile. When selecting a medium, one selects a segment of the public, with its culture, habits, education, expectations, dreams, and the like. The more precisely one discusses selection, the more one defines the public mix. TV viewers are somewhat different from newspaper readers, but this definition is still too vague. Viewers of a particular channel at a particular time of day, and readers of a specific section of a specific newspaper are easier to define. In this sense, the selection of the medium results in a selection of reach, it determines the number and the type of people the message is going to encounter. This must affect the conception of the message in question. As Richard Saul Wurman said at an Icograda conference in Zürich in 1977, "We can only understand things that are related to things we already understand." It is

indispensable to know the language and the experience of the public, so that one can speak their language and refer to issues that they are able to understand.

In summation, for the message to reach the public, it has to be understandable; that is, it has to fall within the cognitive world of the public. For it to do what it is supposed to do, it has to be adoptable; it has to fall within the value system of the public. For the adoption to occur, the public must perceive an advantage in that adoption. This requires a good knowledge of the value system of the public.

The medium affects the message. There is no need to repeat here the work of Marshall McLuhan. Although I would not go as far as to say that "The medium is the message," it certainly conditions it substantially. The process is interactive, because the selection of the medium determines the reachable population, and the reachable population constrains the configuration and the content of the message.

The analysis of the possibilities and limitations of the medium and the public chosen lead to the third definition of the problem, in which design specifications for final production take place.

Third Definition of the Problem

At the third definition of the problem, design and production specifications are defined, and the design brief is written. The aim now is to develop design

criteria to provide precise guidance to the visualizers. Although a certain degree of freedom should be left to the visualizers, there should be clear frames of reference to guarantee that the functional and communicational objectives of the project will be met. In the process of visualization, the designer should be able to understand the totality of the problem and, working within the bounds of the information collected, should be able to interpret the information properly, surprising the production team with superior mastery of the visual language. The development of the design proposal is the time when details of image, type, layout, and color are decided. A prototype is produced and presented to the client.

The elements of visual communication design are typography and image. Typography presents the designer with an extensive set of options, dramatically extensible through the generation of new faces. Images can be conceived as falling into two categories: representational or abstract. Representational images refer to real objects. Abstract images can be ornamental—representing processes or relations— or expressive. A good control of the visual language requires its analysis in formal terms. All visual things have form, tone, and texture. They are formed by dots, lines, and surfaces that can be articulated with each other through three basic organizational possibilities: similarity, proximity, and closure (the three fundamental principles that, according to Gestalt psychology, help integrate and segregate elements in the visual field). These could be defined as follows:

- *Similarity*: The visual system tends to group together those elements that are equal or similar, and segregate the different ones from one another. This can happen at several levels of similarity based on different visual dimensions (such as color, size, orientation, etc.).

- *Proximity*: The visual system tends to group together those elements that are close to one another, and segregate them from the more distant ones.

- *Closure*: The visual system tends to group together series of elements that are placed in such a way as to generate a simple outline.

The importance of the Gestalt theory of perception for design practice and education should not be glossed over. Gestalt theory for basic design has a long, although by no means generalized, tradition that is essential to understanding visual phenomena. Historically, in addition to some initial work done in the area by Josef Albers, Tomás Maldonado is responsible for introducing Gestalt theory extensively in design education in the mid-1950s, at the HfG Ulm, assigning exploratory exercises where visual judgment development was central to the educational strategy (Huff 174).

The following visual possibilities also contribute to visual structure planning:

- *Rotation*: sequential change of orientation of an element

- *Repetition*: a sequence without changes, the simplest form of rhythm

- *Rhythm*: a linear sequence with accents and pauses

- *Pattern*: related to repetition and rhythm but requiring two dimensions

- *Series*: grouping of elements, normally uni-directional, that does not show organized changes among the elements, but shows them as belonging to the same class

- *Sequence*: series of elements that show an organized change

- *Balance*: equivalence of visual weight or attraction at either side of an imaginary median in an enclosure

- *Symmetry*: equality or similarity at either side of a median axis; could be based on two or more axes as well, normally equally distributed around a central point

- *Movement*: dynamic sensation produced by a series of static elements

These organizational possibilities affect the nature of the groupings as much as the elements themselves.

Development of the Design Proposal

During the development of the design proposal, form, content, media, and production technology are defined. The function of the image can be to attract, ornament, or communicate. An image can communicate in support of the text, emphasizing its message. It can concentrate on one aspect of the text, bringing it to maximum attention. It can add new aspects to the message, ones that the text does not include. The image may also be presented by itself, without text, and convey a clear message nevertheless. Roland Barthes defined two basic relations between images and text. In "anchorage," the text fixes one of the possible meanings of the image. In "relay," the text adds an element of meaning that is not in the image, so that the meaning of the message becomes the result of the contribution created by both (Barthes 38).

Typography can also function to attract, ornament, or communicate. Communication in typography centers on the representation of words and sentences, but it is also nonverbal communicating through style, size, tone, and layout.

Presentation to the Client

Presenting to the client requires verbal and persuasive ability. The more systematic the design process has been, the easier it will be to defend the design proposal. At this point, it is necessary to be conversant as much with the general issues of communication

design as with the specific ones that relate to the client's problem.

A precise argumentation and an impeccable visualization are powerful persuasive tools, above and beyond the informational purpose of this presentation. The function of this presentation is, therefore, not only to show where the designer has arrived but also to persuade the client that this is the way to go. The concern for the perfection of this presentation always pays off.

In complex projects, different teams can undertake different stages of development. Research, visual concept, presentation to client, and final production each require different talents and sometimes different specialists. In less complex projects, the same person or team can undertake these stages. To quote Ronald Shakespear, "The presentation of the design proposal is a design problem."

Organization of Production

Once the client has approved the proposal (with or without modifications), it becomes necessary to organize the production program and to decide on production technology, bearing in mind the economic constraints.

It is useful to have a good rapport with two or three production houses that have different or competing qualities and prices. Although there are industrial standards that allow one to prepare electronic files for

any printer, it is advisable to work with a known few, so as to avoid surprises, misinterpretations based on different assumptions, and technological incompatibilities.

Even though, for clarity's sake, it is convenient for me to separate aspects of visual communication design, in practice, the designer works constantly with interdependent variables. Separating economy and technology from communication in this book helps me to establish a clear hierarchy between essential and secondary preoccupations.

Normally, there is a set budget for a project, but sometimes a powerful idea might cause the managers to rethink it. Design can be seen as an expense or as an investment, and its benefits should justify the cost. Sometimes the justification is direct and easy to prove. In other cases, a government might commission a social interest campaign for political reasons, or a private corporation might invest in revamping its visual identity without being able to quantify immediately the generated returns. But in any case, with more or with less ability to measure it, a design investment must be justified by the returns it generates. The designer is a professional equipped to provide advice about communication problems (and solutions to those problems) within a technological and economic framework.

Once the budget for a project is fixed, the designer selects the most appropriate media and technology, maximizing the reach of the message (the number of

people exposed to the message and the exposure time). There are always options, and the designer needs to make choices between possible alternatives. Production costs and media costs (time and space) require careful consideration and cannot just be afterthoughts. The designer is responsible for choosing the most efficient balance between all the factors for each project.

The designer cannot be an expert in media, but must be aware of the decisions that determine to a great extent the success of a campaign. Working with a media specialist, some crucial questions must be answered: Mass media or direct mail? If mass media is chosen: Print or TV? If it is TV: Long films shown a few times or short films with more money left for airtime? An intense showing schedule for a few days or sparse showing over several weeks? Prime time? If it is print media: Large advertisements in a few vehicles or small ads covering a broad scope? In which newspapers and magazines? And what about the World Wide Web? The list of decisions is long.

Once the medium has been chosen, the communication designer prepares the artwork so that, within the existing limitations and conscious of the contexts for implementation, the message can get maximum exposure to the target public. The technology used for the final product must always be borne in mind, for there is no point in making a 4" × 5" transparency of a building for an image that is going to be published on the World Wide Web or in a newspaper. At the same time, if the final medium will afford high-quality

images, it would be a waste to use low-resolution electronic files to do the color separations for a full-color printed annual report on premium coated paper. Technology and economy go hand in hand, and the quality of the final product depends to a great extent on the expertise of the designer.

The most expensive medium is not necessarily the most advisable. Certain messages and certain publics sometimes require low-cost media and technology. In other cases, a low-cost medium might kill a good product if it does not present the product properly. The choice of a medium for the implementation of a message depends on three sets of criteria: communicational, economic, and technological.

Supervision of Implementation

At this stage, the printer takes over the industrial production. This could be followed by distribution. In signage, teaching aids, or packaging projects, a fabricator might build the final products. It is advisable to see proofs, models, or prototypes, and to be at the production shop when the project begins to be produced. The designer should not be misled into believing that, once one has handed in an electronic file and a bunch of specifications, the rest is just mechanical implementation. Many steps and subtle details—the mix of a Pantone printing color, the microscopic lack of pressure of a color roller, or a minor change in paper quality, varnish viscosity, or other production material—might dramatically affect a final result. For the production of works in

electronic media, the risks are fewer and mistakes are easier to correct, but supervision and evaluation are always required.

Clearly, the most important aspect of a design project is at the conceptual level. But the power of a communicational concept can be strengthened or weakened by subtleties of final production. Generally, at this stage, the two most important concerns are the choice of the best technology available (given the budget constraints) and the best use of the selected technology.

Luxury is not necessarily always the ideal. The most effective health campaign in Southeast Asia in 1973 was based on cartoons. They were easy to reproduce and keep; cheap, understandable, and portable, cartoons were more successful than films, slides, videotapes, or TV programs, whose technical requirements dramatically reduced their reach, particularly in the very areas where they were most needed.

It is just as difficult to be a good designer in a rich country as in a poor one, using simple or complex technology, and solving a large or a small project. Design quality is measured within frames of reference, away from absolute and abstract sets of values, and fundamentally independent of production costs. The evaluation criteria must be communicational, functional, and cultural, despite the insistence by many specialized magazines that good design means stylistic innovation, and can only be found in projects with large budgets.

Evaluation of Performance

Once the design is produced and distributed, it is necessary to measure the degree to which the objectives pursued have been achieved. This determines the quality of the design, not its success in professional competitions. There are some competitions, however, that are trying to measure design performance. One of those, organized since 1990 by the Advertising Federation of Australia, is called Advertising Effectiveness Awards. Entries submitted must indicate to what extent the objectives of the campaign were achieved, and prizes are given in relation to an evaluation of merit based on those performance indicators, not on subjective assessments of aesthetic quality.

Design evaluation is an essential component of professional practice. This is the designers' opportunity to determine the quality of their assumptions, and it is the opportunity to incorporate new reality criteria to their design experience. At one level, the evaluation must help to fine-tune details of design and implementation. At a more general level, it must contribute to the designers' continuing professional development.

It is necessary to have a clear and broad idea about the functional aspects a design must respond to. At this point in history, we are well aware of the shortcomings of the Functional Architecture movement of the first half of the twentieth century. It suffered from a reduced concept of what the functionality of

architecture should be. A house is not "a machine for living." Living is not reducible to doing and making. When talking about "what a design should do" in the context of the operational objectives of a design project, one has to put that in a cultural context, a value system, and a humane view of life. Then there is more hope for design quality to be connected to the quality of life.

The environment created by people is a projection of the same people, a sort of self-portrait that should include all dimensions and not just those that can be measured. There is no doubt that the specific aims of a design must be met, but the design should also satisfy cultural needs.

Cultural values frame aesthetics, pleasure, and socialization. A design project should contribute in general to the quality of life. It should be something to be enjoyed and admired as much for its visual aspects as for the intelligence of its concept. Most design problems can be analyzed and solved in a rational way. But once appropriate solutions to the challenges encountered are found, an imagination leap—genius?—sometimes changes the nature of a solution and transforms designed objects into cultural icons.

The value of a design product is, therefore, the result of intelligence in the solution, beauty in the form, and display of imagination. A teaching aid, for instance, that is intended to teach how to add, and only teaches how to add, is an insufficient piece of design. The

product should teach how to add, but it should also promote learning; it should produce pleasure when being used, so that the user can connect pleasure with learning. It should also motivate the user to keep going further, promoting an interest in numbers and letters, quantities and relations; and it should foster observation, memory, dialogue, reasoning, and communication. The product should also help the teacher as well as the learner, and it should add value to the environment and to the activities within which it is used. This is what is meant by cultural value in a product. This is the difference between acceptable designers and those who push the conventional boundaries of the field into new and more meaningful terrains.

It is true that this is not easy, but without considering these kinds of possibilities, it is difficult to produce top-quality design. At the same time, the top priority of the teaching aid discussed is to teach how to add, and the designer should not get distracted by too many other concerns that could lead to a poor solution for the essential function.

Quality criteria in design are often concentrated on beauty and luxury. The third criterion, which came later, is performance, and is normally measured through evaluation techniques. These evaluation techniques frequently relate exclusively to the specific objectives of a product, leaving out the other concerns discussed above. It should, however, be remembered that in addition to the operational success of the product in connection with its expected performance, there are

other dimensions to be considered that could generally be regarded as "softer." These can be defined as cultural, but could just as well have an impact on the economic success of a product, a business, or an idea.

Aesthetics, in the broadest sense, is one of those dimensions that should be considered in every design process. Aesthetics, however, can be a liability when it becomes the only obsession of the designer. This is the disease of many design competitions, whose evaluation criteria decontextualize the design products from the situations that gave birth to them, and concentrate on measuring visual innovation and some unspoken definitions of the beautiful. The exclusive attention to luxury that includes cost, and in some cases technological sophistication, is one of the worst distortions that can affect design evaluation. To sum up, the design problem requires attention in the following areas:

- Communicational issues, including knowledge of perception, cognition, and culture of the public being addressed

- Technical and economic issues that affect production and implementation

- Methodological, managerial, and logistical issues, including coordination of human and material resources

- Performance evaluation, to create feedback and improve the design product

The Design Process: Two Examples

The design process is sometimes characterized by a need to pay simultaneous attention to a variety of interconnected problems, for which it is necessary to confront the whole in an integrated way. Other times, a problem can be solved in a sequential way, confronting one conflict at a time.

One of the first steps in the design process is the distinction between the elements that offer options and those that do not. For example, it could be that the budget and the time line are not flexible in a given project. In this case the designer will have to adapt the flexible dimensions to the fixed ones.

The same methodological situation appears when considering the visualization of a message. In some cases, the visual programming does not present conflicting options, and it can be based on a series of recommendations that arise from research or existing knowledge. As an example, I will describe the visual criteria I developed with Dr. Thomas Nelson at the University of Alberta for the design of a special alphabet (Nelson, Frascara et al.; 1979). This alphabet was intended for children who have a very rare problem with visual information processing that prevents them from learning the form of the letters. Sometimes these children do not even understand that the letters are different from one another. They just see undifferentiated squiggles. These children (and sometimes adults as well) suffer from a lack of short-term memory, and do not remember the path followed

90. Jorge Frascara and Thomas Nelson (1977), *Initial Learning Alphabet/Patterned Alphabet*, Canada.

91. Jorge Frascara and Thomas Nelson (1977), *Initial Learning Alphabet/Patterned Alphabet*, letters mounted on woodblocks ready for use by the learners. The design of the alphabet included the design of an intervention, whereby children followed a series of organized steps through which they did the prescribed training.

by the eyes when looking at the contour of a letter in order to learn it. The perception of patterns is different from the perception of edges, in that it requires simpler functions of the brain. Children who are unable to distinguish one letter from another can distinguish one pattern from another (Figures 90 and 91).

Following these considerations, the requirements for the design of the alphabet were as follows:

- The letters should be placed on visual patterns

- Each letter must sit on a different pattern

- The patterns must be as different as possible from one another

- The pattern for a letter should be the same for uppercase and lowercase

- The letters and their patterns should be usable down to a height of ten millimeters, so that reading distance can be the usual one

- The patterns must not interfere with the letters

- The patterns must overflow the sides of the letters at an appropriate rate so as to generate good letter separation when framing words

- The backgrounds should help children to avoid the rotation of characters

- Color cannot be used because of technical, economic, and perceptual reasons

- It should be possible to produce the design with simple technologies and low budgets

- Three-dimensional versions of the letters should permit easy manipulation for small children with below-normal manual dexterity

- The system should be usable in different languages

In this project, the non-conflictive character of the requirements listed above permitted a sequential resolution, without calling for difficult choices. The list describes the most obvious choices. There were, of course, many more decisions made. But the purpose of the examples in this section is not to describe their resolution in detail, but to show the different kinds of problems a designer may face, particularly in the context of responses to requirements. Many require-ments elicit automatic responses from designers. This is because ordinary routines are built into the practice of the profession. There are, however, other decisions to be made that require conscious attention. These are the requirements that overflow the possibility for automatic response based on experience, requiring conscious, rational, analytical, and sometimes, experimental research responses.

Christopher Alexander suggests that, in the use of a product, it is the things that do not work that attract our attention: a knob that does not turn, a button

that sticks (Alexander 23). By the same token, as designers work, they automatically solve the problems of a project until something appears that resists being solved in the usual way. There is nothing wrong with the use of automatic routines; they are efficient. If one had to invent all the solutions for all the problems presented, for instance, in the design of a toaster or a newspaper, the project would be overwhelming and impossibly expensive.

In a book I designed a few years ago, *Gramsci x3*, by Wilfred Watson (Longspoon Press, 1983), the situation was less linear. We were given the size of the book (5.5" × 8.5"), the number of pages (192), and the number of copies (500). The financial variables confronted were as follows:

- Paper quality

- Number of illustrations

- Colors

- Number of pages

- Height of the print area (bleeds or not, and where)

The conflicting design variables were as follows:

- Book produced for readers or for actors (the book contained three plays)

- Integration or segregation of image-text:

 – If text and image were integrated, how to avoid conflict

 – If it were necessary to use a different color for the images, how to avoid exceeding printing budget by compensating with savings elsewhere

The final production solution was based on the following decisions:

- Paper quality slightly better than the usual in order to permit 150 lines per inch for the screening of the images, so as to avoid conflict with reversed-out type

- The fifty-four illustrations were distributed so that they required six plates in color (each plate printed eight pages); four with halftones and two in line art

- In order to accommodate the expense in color, the height of the printed area was taken to the maximum so as to reduce the number of pages

From a communication perspective, decisions were as follows:

- Book designed for readers rather than for actors

- Integration of texts and images through over-printing, so as to permit continuity of text while using the images as dramatizing backgrounds

- Change of second color between plays, organizing the pagination and plays so that changes of play coincided with changes of color

Needless to say, these decisions were made in close collaboration with the editor and the author. We frequently talked about "mise en page" as equivalent to "mise en scène," the conception of a book being similar to the staging of a play, and the role of the book designer being similar to that of the stage designer (Figure 92).

92. Jorge Frascara (1983), sample page, Wilfred Watson, *Gramsci x3*, Longspoon Press, Edmonton.

The Practice: Professional Areas

VISUAL COMMUNICATON DESIGN COVERS FOUR basic areas with somewhat blurred boundaries. The classification presented here is based on the idea that each area requires different skills and different levels of education, and even, in some cases, the contribution of outside experts. This is especially true for projects of high complexity. The areas are: design for information, design for persuasion, design for education, and design for administration.

Design for Information

The vast and varied categories of design for information include: publishing (books, magazines, newspapers); alphanumeric tables (timetables, directories); the informational aspects of tickets and other administrative instruments (theatre tickets, airline tickets, stock documents, banknotes); graphs

and diagrams (visualization of abstract, quantitative, or topographic information); some kinds of teaching aids (informational wallcharts); instructions for use (manuals, game rules); reports, programs, catalogues, informational displays; control panels (sound systems, airplane cockpits, driving instruments); signage (symbols, signs, systems); maps and plans (without including cartography, or blueprints for architecture or engineering that, although they fall within the field of information design, are not tasks of information designers); and navigational tools for computer interfaces (Figures 93 to 106).

Information design consists of two distinct steps: the organization of the information, and the planning of its visual presentation. These tasks require the ability to process, organize, and present information in verbal and nonverbal forms. The organization of information requires a good grasp of logical structures and cognitive processes. The visual presentation of information requires solid knowledge of the legibility of symbols, letters, words, sentences, and texts. It also requires a keen understanding of the informational capacity of images, and of their effective articulation with texts.

Visual detection and acuity, and comprehension, are central concerns in information design. The information designer should be conversant with perceptual and cognitive human factors. Sometimes space constraints and lack of design ability result in difficult situations for the user, from an information design point of view. Sometimes the intelligence of

continued on page 138

93 and 94. Meta Design (1990s), Berlin Transportation map. Full view and detail.
(Reproduced by permission, © Erik Spiekermann)

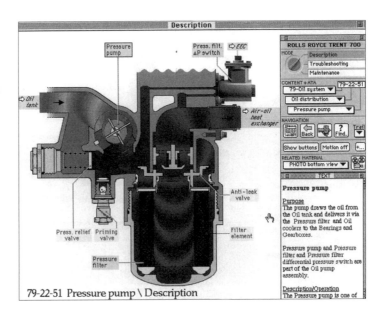

95. Pressure pump diagram (1990s), Rolls-Royce Aerospace CD-ROM (Reproduced by permission).

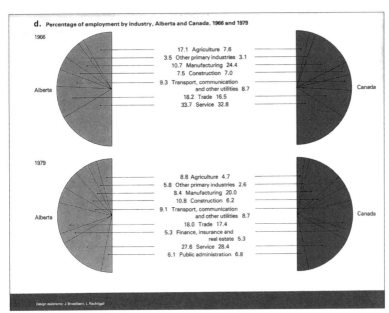

96. Jorge Frascara (designer) and Leszek Kosinski (researcher) (1980). "Percentage of Employment by Industry, Alberta and Canada, 1966 and 1979." *Education and Labor Force*, Alberta Advanced Education and Manpower. Diagram for one of a series of six statistical posters.

97. The DELPHINS research flight deck. (Reproduced by permission, © E. Theunissen and T. Etherington)

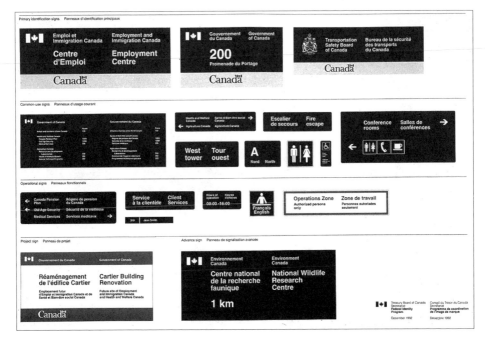

98. Government of Canada (1967), Federal Identity Program, examples of typographic layout.

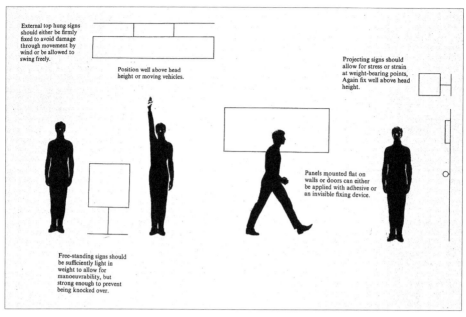

99. Pentagram (1960s), diagram for location of signage, London Heathrow Airport signage system (Crosby, Fletcher, and Forbes 49). (Reproduced by permission, © Alan Fletcher)

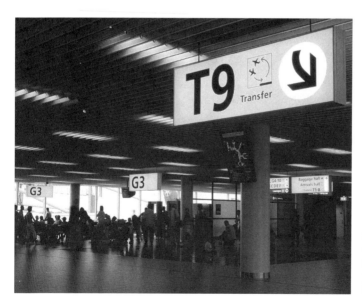

100. Paul Mijksenaar, Schiphol airport signage system (1991–2001). (Reproduced by permission, © Photo Bureau Mijksenaar)

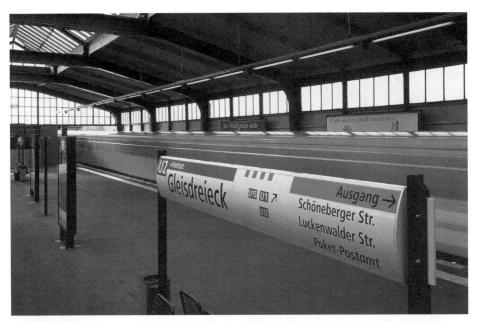

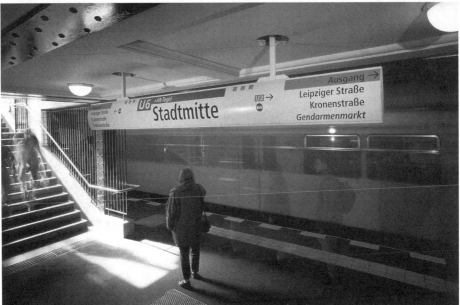

101 and 102. Meta Design (1990s), signage system for the Berlin subway. (Reproduced by permission, © Erik Spiekermann)

103. (*left*) Diseño Shakespear, Buenos Aires (1995), identity and signage system for the Buenos Aires subway. Project Director: Lorenzo Shakespear. The identity factor was always important for the Shakespear: It was more than just a subway map. Consideration of sociocultural and historical dimensions resulted in a very particular case of identity where the act of rescuing the word "subte"—slang for "subterraneo" (underground/subway)— sanctioned the value of popular language as a powerful identity tool. So branding and signage came together. (Reproduced by permission, © Estudio Shakespear)

104. (*below*) Diseño Shakespear, Buenos Aires (1995), identity and signage system for the Buenos Aires subway. Project Director: Lorenzo Shakespear. (Reproduced by permission, © Estudio Shakespear)

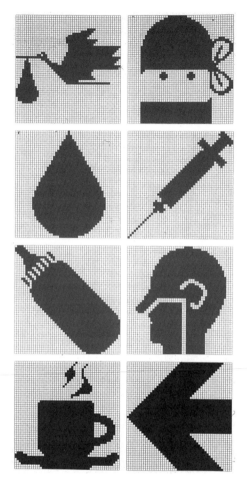

105. Diseño Shakespear (1976), signage system for a maternity hospital in Buenos Aires. As Ronald Shakespear put it, this was a special kind of hospital: patients there were healthy and about to give birth. He thought the signage should create a joyful atmosphere, over and above orienting users. (Reproduced by permission, © Estudio Shakespear)

106. BRS (1985), signage system for an office. There is no need to scream. The visual solution of a sign system should consider the need to adapt loudness to the actual needs of a place. An office is not an airport. (Reproduced by permission, © Niko Spelbrink)

the designer leads to solutions that are visually simple, but rich with information and eminently comprehensible, as is the case in Marey's train timetable (Figures 107 to 110).

Design for Persuasion

Design for persuasion and design for education are both directed at affecting the behavior of the public. Design for persuasion can be divided into three areas: advertising (commercial and non-commercial); propaganda (political and ideological); and social interest communications (health, hygiene, safety, etc).

Commercial Advertising

In commercial advertising, the designer contributes to the marketing of consumer products and services.

107. An airline ticket is a perceptual and cognitive challenge to the user. All the experience we have in information design should help to categorize the information, so that each user can easily identify the portion of relevant information.

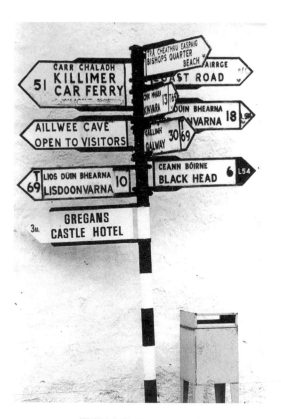

108. It is necessary not only to design every informational element properly, but also to control the implementation of messages. (British country road intersection)

109. Typographic difficulties can sometimes be challenging for the user. These containers of caulk and glue present directions and warnings in a type size that challenges normal vision, let alone the visually impaired.

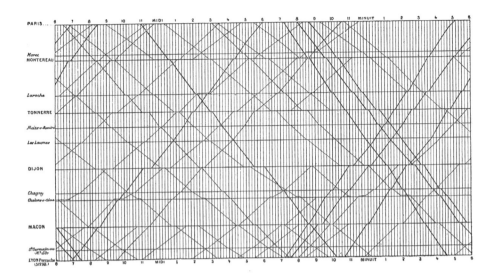

110. In some cases, like this one, a high information density is successfully resolved through an ingenious diagram. The vertical lines represent ten-minute intervals; the horizontal lines the railway stations between Paris and Lyon; and the diagonals the trains. E. J. Marey, *La methode graphique*. Cited by Edward Tufte (31).

Large-scale work in this field is supported by marketing research—a discipline supported in turn by sociology, anthropology, economics, and several branches of psychology. The designer in this case contributes to the visual interpretation of the recommendations developed by the marketing experts. This should not be a passive role. The designer must be an active and imaginative participant in the conception of the communicational product, and not just a passive interpreter of the requirements provided by the marketing experts. This role of advisor has to be earned with believable and convincing arguments; it is not possible to gain respect from others by arguing that one has better taste or a more developed sense of intuition about design.

Work in the advertising field requires the designer to be up-to-date with current fads, fashions, and popular

culture, as well as the multifaceted ways in which language is used, from literature to science to street slang. Given the ephemeral character of many advertising campaigns, designs must immediately show their efficiency. The designer must be flexible, alert, and able to incorporate changes and adjustments to the pieces, integrating new elements or considerations whenever situations change or new information suggests the need for different approaches. In general, designers in advertising work with short texts and images with high visual power. In some cases, the balance can be different, depending on the subject or on a current trend. Titles, in many cases, replace images as the main focus of attention. Advertising designers must have the necessary skill to lead the reader from the title to the text and on to the image, maintaining the reader's curiosity and attention through a series of organized steps that articulate the connections between the different components.

The task of the advertising designer does not end with the design of advertisements. From packaging to corporate identity, a large field of action contributes to commercial communication systems. Advertising can take the form of exhibitions, direct mailings, Web sites, video clips, promotional gifts, sponsorships, flyers, or posters. Advertising campaigns often cost millions of dollars to place in mainstream media. The responsibility of the designer is enormous. One should be conscious of the possible impact of the models of human behavior portrayed in an image that will be reproduced thousands of times. Slogans and images to

sell cars very often use humor, but different people may read them in different ways. What some people find funny, others find disturbing, while others might develop antisocial behaviors. Persuasive communications in commercial advertising involve a delicate cultural balance. The general public, to a great extent, adopts value systems based on what the media promote and portray, and this can sometimes involve controversial issues, such as the glamorization of risk or the promotion of questionable social roles (Figure 111).

These fields often require the participation of other specialists, so the designer must always be prepared to work as part of a team. Packaging design, for instance, requires the participation of industrial designers (specialists in materials and industrial production processes, storage, transportation, and recycling). In other cases, architects, photographers, and filmmakers are required for the solution of communication design projects.

Corporate identity design is the departure point for the commercialization of an organization, and represents one of the most complex challenges for the communication designer. Corporate identity design establishes patterns for all communications—internal and external—of an organization. It goes beyond graphics into architecture, the attire of personnel, employee behavior, and every other detail that defines a firm. The image of a firm in a market is the result not only of its graphics but also of all its levels of action—controlled and uncontrolled, private and public. The job of the visual communication designer

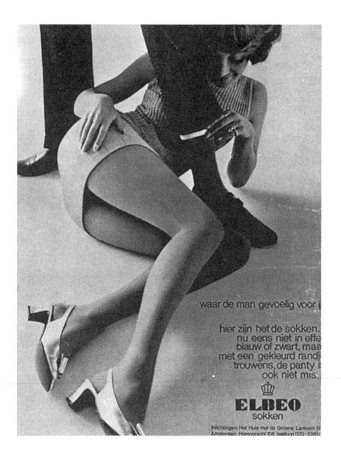

waar de man gevoelig voor i

hier zijn het de sokken.
nu eens niet in effe
blauw of zwart, maa
met een gekleurd randj
trouwens, de panty i
ook niet mis.

ELBEO
sokken

Inlichtingen: Het Huis met de Groene Lantaarn N
Amsterdam Herengracht 106 telefoon 020-23614

in this context is to create frames of reference for all products, services, and activities of the firm. For commercialization purposes, some businesses may present lines of products in the market as unconnected with each other. Sometimes they do this to pretend that competition exists. Other times they exploit different economic levels of the market without polluting a brand with another one that belongs to a totally different social context. In these cases, businesses tend to hide the common origin of their products.

111. Selling pitches sometimes promote social role distortions. This is an advertisement for Elbeo (men's socks), published in the Netherlands (Tubbergen 27).

Many designers regard corporate identity as not belonging to the marketing field, given that the graphics that have to be developed include letterheads, forms, bills of sale, administrative forms, signs, and the like: elements not usually related to advertising. As long as those elements contribute to the identity of a commercial firm, however, they all contribute to its commercial performance. The corporate image of non-commercial organizations could be regarded as different, but to a great extent it is similar, in that the visual identity of a socially oriented organization will always need to dwell on the promotion of its ideas, engaging in the persuasive dissemination of political or social positions.

Identity is one of the most powerful assets of a commercial firm or of a cultural organization. Not only does the consumer product industry dwell on image positioning, but publications do as well (Figures 112 to 116).

Magazine covers, editorial material design, and the design of newspapers represent a terrain where the identity emerges from decisions of detail, particularly connected to typographic design and layout.

Non-Commercial Advertising

Non-commercial advertising includes the promotion of socially oriented public events, ideas, services, or facilities. Generally, this advertising is financed by governments or nonprofit organizations with a view toward contributing to the well-being of people.

continued on page 147

112. Thirst: Rick Valicenti and Mark Rattin, Absolut Vodka, advertisement. (1994) The notion of identity is central to the marketing positioning of a product. Absolut Vodka is an excellent example of a campaign that was loyal to its program and lasted many years. (Reproduced by permission, © Rick Valicenti)

113. Bonnie Sadler Takach, visual identity for Theatre Alberta (1996–1999). An identity can have a wide range of variability—as long as it is planned variability—and still be perceived as a unity. (Reproduced by permission, © Bonnie Sadler Takach)

114, 115, and 116. The identity goes well beyond a logo. In the publication industry, the covers and double spreads of magazines, and, often, even advertisements, maintain a coherent identity. Within a publication, however, different sections frequently require a somewhat different visual treatment (*Tipográfica 50*, January 2001). (Reproduced by permission, © Rubén Fontana)

146

The intention of these organizations is methodologically similar to that of businesses, in that they promote something in the hopes that the public will adopt it. Communication strategies adopted by nonprofits often prompt a weak response because of a lack of resources that leads to the use of more intuitive approaches rather than approaches based on complex motivational studies (as tends to be the case in commercial advertising). In this field, it is common practice for the client to provide information that does not go beyond the expression of good intentions, hoping that the designer will produce a persuasive miracle. The emphasis in these communications tends to be aesthetic and informative, even though the intention could be persuasive (Figures 117 to 121).

For messages to be persuasive, however, it is necessary to know the public extremely well, to know what the public is sensitive to, and to understand its ideals and desires (*User-centred Graphic Design* 61). Persuasive messages act in two ways: They scare people by making it clear that certain negative things the target public is sensitive to can indeed happen. Or, they can offer a benefit to the public in a believable way, and in line with the public's value system. "What's in it for me?" people ask themselves. If there is nothing, the campaign fails. A detailed description of something does not guarantee a behavioral change in the target population. There is a great deal to be learned about persuasive communications from the campaign launched in 1990 in the state of Victoria, Australia, by Grey Advertising and the State of Victoria Transport Accident Commission. It has been running since then, and traffic injuries have fallen by 50 percent (Figure 122).

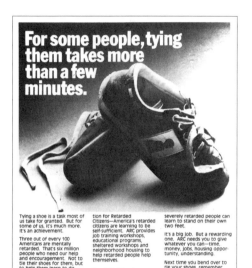

For some people, tying them takes more than a few minutes.

Tying a shoe is a task most of us take for granted. But for some of us, it's much more. It's an achievement.

Three out of every 100 Americans are mentally retarded. That's six million people who need our help and encouragement. Not to tie their shoes for them, but to help them learn to do things for themselves.

Through the ARC—the Associa-

tion for Retarded Citizens—America's retarded citizens are learning to be self-sufficient. ARC provides job training workshops, educational programs, sheltered workshops and neighborhood housing to help retarded people help themselves.

Over 85% of America's retarded citizens can lead productive lives. Even the most

severely retarded people can learn to stand on their own two feet.

It's a big job. But a rewarding one. ARC needs you to give whatever you can—time, money, jobs, housing opportunity, understanding.

Next time you bend over to tie your shoes, remember those who need a little more help—and remember that you can give it.

arc
Association for Retarded Citizens
When you give help you give hope.

117. Advertisement by ARC, the Association for Retarded Citizens (1984) (renamed the Arc of the United States in 1992). Communications for social purposes often use sophisticated rhetorical strategies; however, this does not guarantee their persuasive success. (Reproduced by permission, © Arc of the United States)

118. Trio Drzewinski (1986), antinuclear poster. This is an extremely smart image, but does it work?

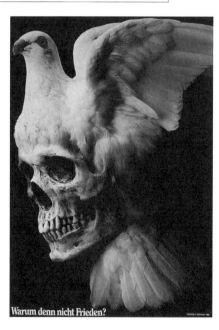

Warum denn nicht Frieden?

119. Günther Kieser (1982), peace poster. (Reproduced by permission, © Günther Kieser)

120. Alf Mork (1980), *Young lungs fade quickly if you start smoking before age 15*, poster. (Reproduced by permission, © Alf Mork)

121. Peter Stone and Kaa-Nee-Ta (1985), *Consumption of alcohol may impair your ability to drive.* Some images leave a long-lasting impression, perhaps making viewers think about the consequences of a particular action.

122. Grey Advertising (1990s), TV screen still from traffic safety campaign for the Transport Accident Commission of the State of Victoria, Australia.

Political and Ideological Propaganda

Political and ideological propaganda, in addition to informing, intends to affect public opinion (Figures 123 to 126).

123. Grapus (1983), event-promoting poster. Posters are generally a weak deterrent to war. In this case, however, the poster is an invitation to an event against arms proliferation. Even though a good poster can promote an event efficiently, it certainly cannot stop the proliferation of weapons. It is useful to have a realistic perception of what it is possible to accomplish with communication design. (Reproduced by permission, © Pierre Bernard)

This is possibly the most conflicting terrain in visual communication design. Although the terrain does not require a specialization different from advertising, the support team changes to include experts in politics. Electoral campaigns are an example of this area. David Ogilvy dedicates four pages of his book to the ethical, legal, and economic excesses evident in political campaigns. He begins his discourse by saying: "There is one category of advertising which is totally uncontrolled and dishonest: the television commercials for candidates in presidential elections" (Ogilvy 209).

124. Grapus (1977), *On y va* (Let's go, everybody, to Ivry 4–5 June, for the celebration of change), poster promoting an event. The composition of the text requires the active participation of the reader in the process of interpretation. This parallels the content of the message, which calls for the participation of people in the event. The poster is also an invitation to think, based on respect for the intelligence of the audience. (Reproduced by permission, © Pierre Bernard)

125. Gérard Paris-Clavel (1999), *Dormez citoyens/Les medias veillent* (Sleep, citizens/The media watch for you). Postcard and poster. The central dot is blue on the left and red on the right in the original. (Reproduced by permission, © Gérard Paris-Clavel)

126. Gérard Paris-Clavel (1997), *Garçons/Filles* (Boys/Girls), sex education for teenagers. The booklets were distributed free by a large number of volunteers who waited for the right time to pass them out to teenagers. They are based on quotes selected from interviews with teenagers. (Reproduced by permission, © Gérard Paris-Clavel)

Design for Education

In design for education, the work of visual communication designers moves between information and persuasion. Although these poles are of prime importance for understanding the profession, and although they are present in almost any communication design project, it is useful to understand that design for education includes those concerns, but it also extends to other aspects that deserve special attention.

Education cannot be reduced to the transmission of information. This is clear when one makes a distinction between education and training. Training involves the acquisition of already existing information and skills, while education is directed at the development of the person. The active participation of the user of educational materials is central in this case. Persuasive communications intend to affect the behavior of the public. Although educational materials have the same intention, the purpose is different. It is different because in education one always intends to persuade individuals to think on their own, to judge, and to make decisions on the basis of personal reflection. In sum, the intent of the persuasive message is normally to convince, while the educational message intends to contribute to personal development.

Within the educational context, one can find materials that are mainly persuasive or mainly informational.

The sum total of the experiences in education combines different modes of communication toward the main objective of fostering the development of the individual within certain social values and practices.

Every school has teaching aids, which are mainly for reference, such as maps, diagrams, charts, drawings, and the like. There are also persuasive materials, such as chronicles of patriotic or heroic feats carried on as romantic actions in which the leading characters are more beautiful than the enemies; hygiene charts that show what happens if one does or does not take care of oneself properly; models of social behavior, and so on. In addition to these materials, there are educational materials that offer a variety of possibilities for interpretation; they require value judgments and the active participation of teachers and students for their use.

In this category, it is worth looking at an interesting project done in the 1970s by Ed and Jane Bedno for racial integration at Virginia Commonwealth University (Figures 127 to 130).

One of the components of the package called *People Are People Are People* includes a series of photos that show ambiguous but ordinary scenes at secondary schools. This package also includes caricatures of people one could find in this context. These components intend to promote the elimination of preconceptions, and to help people discover how different points of view can lead to different

continued on page 156

127. Ed and Jane Bedno (1974, Virginia Commonwealth University), cover design for *People Are People Are People,* racial integration campaign produced by the Division of Telecommunications, State Department of Education, Richmond, Virginia. (Reproduced by permission, © Ed Bedno)

128. Ed and Jane Bedno (1974, Virginia Commonwealth University), characters to hang around the neck for role-playing. (Reproduced by permission, © Ed Bedno)

129. Ed and Jane Bedno (1974, Virginia Commonwealth University), cards for the students to use to introduce themselves and begin conversations. (Reproduced by permission, © Ed Bedno)

130. Ed and Jane Bedno (1974, Virginia Commonwealth University), situations presented in pictures to be interpreted by the students. (Reproduced by permission, © Ed Bedno)

interpretations of the same scene. The material is an invitation to a critical development of value judgments.

In this sense, the design of educational materials differs from the design for informational and persuasive materials, adding a third pole to the territory of visual communication design. When preparing teaching aids, it is fundamental to remember that the learning experience is better when it is done in an active way. To design according to this, the designer, more than producing teaching materials, plans teaching situations in which students and teachers complete the design plan.

This position, which considers the receiver to be an active component in the communication process, puts the term "receiver" in a new perspective. In traditional communication theory, the term has a definite passive connotation. The reception of messages, however, is never passive. It is apparently more passive than the transmission of messages, but it always includes active behaviors that are indispensable for the interpretation and comprehension of the message confronted. When reading this book, the reader is not receiving a given message. Interpretation is a constructive process, one that contextualizes the material through cognitive and evaluative activities on the part of the reader.

Needless to say, design cannot act alone in the development of educational materials, and several branches of psychology (educational, developmental, cognitive, etc.) become indispensable allies.

The Education of the Public

Design applied to public health and safety is based on the three areas discussed above. Although its objective is of such importance that one is tempted to assign to it a special status, it works in methodological terms through the three types of design already discussed: information, persuasion, and education (Figure 131).

In general, governments finance the designs that work toward educating communities about health-related issues. Sometimes pharmaceutical companies produce pieces as part of their public relations programs; oftentimes, these pieces are directly connected to the promotion of specific products. Design for industrial safety is often produced by the firms that control workspaces, but it is generally reduced to a few signs bought from local printers, which are not based on either a good analysis of causes of injury or research in industrial psychology.

131. *Suddenly, you're a good driver* (2000, Alberta Motor Association and Mission Possible Coalition). Social marketing initiatives are often implemented by nongovernmental and commercial organizations in connection with their fields of interest. This is usually done in the context of long-term goals and public image development. (Reproduced by permission, © Don Szarko)

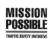

132 and 133. Graphic symbols for industrial and public safety. To inform people about a dangerous situation is not necessarily enough to solve the safety problem. In areas such as industrial safety, the success of the design is measured by a reduction in the number and severity of accidents. Assuring public safety requires a policy that involves more than just a graphic campaign. Symbols from a report that I produced with Tony Yau for the Canadian Standards Council: "Evaluation and Development of Safety Symbols." Series of three symbols selected for eight referents according to the ISO-established "Appropriateness Ranking Test" method (ISO 7001).

The intention of these communications is partly informative, partly educational, and partly persuasive, although the persuasive aspect is more generally based on information than on motivation. Messages in this field take the shape of advice, sometimes appearing as commands, sometimes as prohibitions. There is an urgent need for research in the fields of public health and public safety, that is, safety in traffic, industry, sports, and at home (Figures 132 and 133).

One of the fundamental problems with the use of graphic symbols is the clarity of their meaning; often they are not in the right place or they are not sized properly. Clear symbols help to convey messages, but, in addition to being understandable, they have to be visible. Between 1979 and 1984, I led a working group of the ISO (International Standards Organization)

that developed the first research-based criteria for the size and placement of graphic symbols for public information in public spaces. This was published as ISO Technical Report 7239. Although this was developed for general use in public spaces, its methodology is transferable to any other situation where graphic symbols are used (Figure 134).

Normally, the design for public and industrial safety requires brief messages, usually with high visual impact. It is a challenging field, given that the power of a message is lost over time. To maintain their visibility, one has to think about systems of messages, rather than about a few permanent features in high-risk places, because they tend to disappear from sight when people get used to them. In driving, as in industry, injuries tend to happen more in the second

134. Jorge Frascara for the ISO TC 145/SC1/WG2. Recommendations for size and placement of graphic symbols in public spaces, ISO Technical Report 7239 (1984). A first attempt to establish criteria for the size and placement of graphic symbols based on empirical evidence.

year of activity than in the first one. It seems that excessive confidence, coupled with a failure to pay attention to basic procedures, leads to mishaps.

The design of health-related and accident prevention communications requires the support of different specialists, such as physicians, psychologists, and sociologists. In many cases, particularly in connection with industrial and traffic safety, business managers, industrial designers, and engineers can contribute to the development of strategies aimed at increasing the safety of a place.

Design for Administration

Design for administration is a category all its own. It does not involve information, persuasion, or education, as the previous cases do, but it contributes to the organization of certain communications inside administrative systems. Design for administration includes the design of forms, tickets for transportation and shows, bills of sale, organizational diagrams, internal communications, and in a separate sub-category, the design of banknotes, postage stamps, and other similar instruments.

The design of forms has special characteristics. When designing forms, the designer prepares the structure of a possible message, analyzing problems of categories, hierarchies, and sequences without getting into the specifics that will be provided by the user. In this way,

the design of forms structures the information to be provided by the person filling out the form.

Rather than being the design of messages, the design of forms and other similar elements involves the design of structures aimed at guaranteeing order and pertinence of the information to be compiled. It is somewhat akin to the design of grid systems in publication design, in terms of establishing an ordering system, but it goes further in that it involves not only physical limitations but also content requirements (Figures 135 and 136).

135. Samples of different ways of making questions and limiting answers in administrative forms (Wright, 153).

Particulars of your household

4 Full name of each person living with you—non-dependants should be included only if you are the householder (see note **C**). BLOCK CAPITALS PLEASE—*first names followed by surname*	See Section 5 below	State relationship to you or write "No relation"	Date of birth if under 21	Give name of school if attending. Write *D* if dependant (see note **D**), *P* if of pensionable age (see note **E**), *SB* if receiving supplementary benefit

5 Please write the following letters where they apply in the space after the names of the members of your household above: *B* if registered as blind; *H* if registered handicapped person; and *E* if an expectant mother

Figure 12. Example of a question format making heavy demands on the form-filler's memory (from Wright and Barnard, 1978).

136. Sample of form/ questionnaire that requires an enormous memory effort from the user (Wright 167).

The complexity of the design of transportation tickets, theater tickets, and other similar devices lies in the need to produce different messages for different users on the same surface. Price, date, seat number, time, place, door, regulations, and the like, are topics of information directed at different users, and must be clearly presented to avoid confusion and to make for efficient and speedy recognition (Figure 137).

Normally, this is done poorly, and all users, particularly the individuals who only occasionally go to a given facility, have to solve a difficult problem when attempting to separate relevant from irrelevant information.

The design of securities also has its specific requirements, and information design plays a substantial role

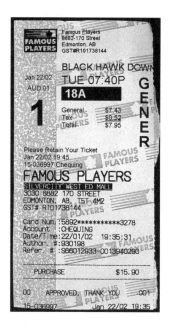

here as well. A banknote, for instance, must clearly show the amount and the country that it represents. In this connection, the design of banknotes is related to the design of identities, because a banknote represents the country it belongs to and becomes a kind of promotional piece. This proved to be a major difficulty for the design of the Euro bills.

Security is the essential and primary concern in this area: A banknote should be designed in such a way that forgery is difficult and deterred. Among the design strategies used are portraits, because they can reveal differences, even to the untrained eye; filigrees with positive and negative lines, which make photographic reproduction impossible; sophisticated production techniques, including holograms; and special papers (Figures 138 to 141).

137. Ticket for a show. Users of this ticket (public, controller) must make a considerable effort to find the information relevant to them.

138. Typical drawings for banknotes. Canadian $20 bill.

139 and 140. The use of dark and white lines creates difficulties for photographic or reprographic forgery. Scanners are better than photographic processes, and this has pushed the technology of securities into other expensive techniques, such as holograms, to maintain the security of instruments with high value (such as banknotes with large denominations or credit cards). Front of American and Canadian $10 bill.

141. The old American $10 bill. The new version is simpler (Figure 139), but not necessarily more legible.

The new design of the American dollar has improved the general clarity of the surface, but the amount in numbers is no clearer, and the uniformity of size and color has been maintained across all denominations. Two good opportunities have been lost to help visually handicapped, distracted, or aging people to determine values.

The design of the Euro has opted to avoid portraits, losing an opportunity for the common user to tell forgery from real. Europeans have decided to rely on high-tech holograms and printing sophistication (Figures 142 and 143).

142 and 143. Front and back of the 20 Euro bill. The design relies on technology and dismisses the use of portraits, which are usually a good way for the layperson to identify a forgery.

Postage stamps also have some unique requirements (Rose 9). Samples of poor design in this area include postage stamps with solid black surfaces produced in Mexico, in which it is impossible to read the date of cancellation if it falls on the black background (Figure 144).

In some cases, the date of the cancellation serves a legal purpose, but the use of large black areas on the postage stamp may make it impossible to discern the date of cancellation. Design in this area requires advice from criminologists, administrators, technologists, and bureaucrats who each focus on different aspects of the design of securities.

144. Mexican postage stamps. The cancellation rubber stamp in some cases could be useful for legal purposes. Having solid black areas in the postage stamp might create difficulties when trying to establish the actual date on which a letter was postmarked.

Elements and Systems

Designers often work on the development of isolated elements, such as a book, a logotype, a poster, etc. They also work on the design of systems; that is, families of elements that respond to planning decisions that affect current and future components. This is the case in the design of sign systems, alphabets, corporate identities, magazines, and so on. The design of elements and the design of systems require quite different skills.

The concept of system is essential to the understanding of the designer's job. Even in the case of isolated pieces, the designer must understand the systems within which the specific pieces operate. The design of systems requires special skills for the categorization of information and for the conception of abstract structures that organize the production of the necessary, and of the possible. A design program should be able to take into account not only all the current needs of a client but also that client's potential needs. When this is not done, the systems collapse or degenerate over time, suffering from the progressive incorporation of pieces that are not in line with the established guidelines.

Two Dimensions, Three Dimensions, and Movement

The designer's job can be categorized according to its physical dimensions. Designers work in two

dimensions, three dimensions, and movement. The following table shows a summary of professional areas and where they belong in connection with these categories.

2 DIMENSIONS			3 DIMENSIONS
ISOLATED ELEMENTS & SYSTEMS	**SEQUENCES**	**MOVEMENT**	
Advertising	Audiovisuals	CD-ROMS	Exhibitions
Alphabets	Brochures	Movies	Packaging
Banknotes	Books	TV	Point of sale
Book covers	Guides	Videos	Signage
Charts	Magazines	Web sites	
Clock/watch faces	Manuals		
Control panels	Newspapers		
Diagrams	Periodicals		
Dials	Storyboards		
Flyers	Teaching aids		
Forms			
Graphic symbols			
Logotypes			
Magazine covers			
Maps			
Postage stamps			
Posters			
Signs			
Super-graphics			
Tickets			
Timetables			
Visual identities			

Computer Technologies and Communication Design

THE ADVENT OF THE COMPUTER HAS HAD A
double influence on visual communication design.
On the one hand, it has changed the means of
production, eliminating drafting tables, rulers, set
squares, rubber cement, and the like. On the other, it
has brought about a different way of accessing and
interacting with information, through the World Wide
Web and CD-ROMs. Digitalization has permitted the
creation of multimedia, which concentrates in one
production tool the capability to handle moving visuals
and sound. To some extent, this had already been
accomplished by film. But the difference is that with
the computer media it is possible to randomly access
data sources, and—under certain conditions—to
modify the data. New areas of work have been opened
to visual communication design, and a change of profile
has affected the daily life of the designer.

The central problem of communication design
has not changed: to create visual messages for

information, education, administration, and persuasion. Working in this field to affect people's knowledge, attitudes, and behaviors is just as challenging as it ever was. Until around 1980, however, design production was quite different from today. Since then, multimedia has opened an enormous new field of activity.

The Computer as a Production Tool

A few challenges have replaced other challenges. Until around 1980, one had to have perfect control over geometry and craft to produce accurate originals for reproduction to be passed onto the printer. Today, one has to have perfect control of the current computer programs to permit a smooth transition from the design studio to the print production shop. Printing technology has not changed, but practically all the production steps that take place before printing have.

One of the major challenges for designers in connection with production is to be responsible for the completeness and accuracy of all elements in the final electronic file, including the composition of texts. Although designers in the past always knew about typography, there were professional typesetters who, when they were really professional, did a fantastic job. Today, this profession has disappeared. Designers not only lay out the texts but also set them. That is, one has to get involved in all details, such as kerning, line breaks, and minor adjustments of all sorts.

Furthermore, typesetting shops used to have professional proofreaders, but no longer. Now the designers pass on to the printer the finished product, taking responsibility for accuracy and completeness. It is customary today for designers to spell out an agreement with clients that responsibility for accuracy of texts lies with the client, and that nothing goes to press without the client's signed approval.

The need to attend to detail has always been there. And good designers in the past not only looked at every letter and every space in a text but also busied themselves in the print shop, making sure that all the production steps were done properly. The removal of the physicality of the artwork in visual communication design production can be deceiving. Some beginners are surprised when they see that the color of the final printing is not like the color of their inkjet printer, which in turn was somewhat different from the color on the computer screen. It is indispensable to be conversant with those differences, and to use the necessary reference materials that allow one to foresee how a printed product might actually look.

Printing colors depend not only on the printing inks but also on the paper qualities and surface finishings. The same color will appear dramatically different on uncoated newsprint, uncoated bond, coated matte, or coated glossy paper. There is also a difference if one varnishes the color (matte or gloss), and if one asks the printer to pass a color through the press twice. The finished quality of anything that one produces in the computer can also be deceiving: Things look good,

they look professional, even if the design and the concept are not that good. It has become necessary to warn students about this deceiving aspect of badly designed but neatly produced roughs.

Technology in visual communication design is not limited to computer technology. Normally, there are four technologies involved: photography, computers, papers, and printing. Each one of them has to be handled properly if a final job is to be as good as it can be. Each one of them can destroy a good intention.

Production work today, although based initially on the computer in the design studio, still requires a good rapport between the designer and the printer. It is always advisable to become fully informed about the printer's requirements, the steps the printer will follow with the disk you provide, and the way you can prepare the files so that no surprises occur when the files get transferred into the printer's systems.

Design for Electronic Media

I call this section "Design for Electronic Media," not "Interaction Design" or "Interface Design," because the term "interaction" is used wrongly today to assign to computer-based design the exclusive use of interactivity. A newspaper is interactive, and in so many ways. We jump from page to page, focus on what we please, tear apart the sections we do not

intend to read, cut out a classified ad selling
something that we may want to buy, circle with a
pen the ad of the film we intend to see tonight,
photocopy something, and then put the newspaper in
the recycle bin. With a newspaper, interaction is not
only cognitive or visual, but also physical. The same,
to a great extent, applies to textbooks and to books for
any kind of research purpose. Back in the Middle
Ages, "marginalia" (notes on the margins) were born
from annotations by informed readers.

Interaction is our human way of dealing with things
and with information. Interaction is central to
communication. We must forget the old ideas of
"transmitter" and "receiver": Real people do not
receive information. For stimuli to become
information, one has to actively interpret, through
a variety of actions, whatever one is confronting.
To live is to interact. The computer world does not
own the function.

As for interface, it is that which is in between. The
control panel of anything is an interface, from a gas
stove to a TV set. By extension, Gui Bonsiepe argues
that all design involves interface design. He contends
that any task related to an artificial object benefits
from good interface design, that is, from a good
understanding on the part of the designer that every
object that is meant to be used should communicate
clearly how it is to be used and permit that use with
ease. Design for electronic media has opened up a
new series of problems. In the interaction with a
newspaper, a book, or a magazine, we immediately get

a sense of the size of the universe we are entering. We can browse it easily, always having a sense of where we are in that universe. The design of interfaces must respond to that need—that sense of "Where am I?"—in terms of both the profile of the universe where one is and one's location within it. A major concept within design thinking that comes into play here is the notion of usability: How easy is it to use the device? How much does the interface let me know what is behind the screen? How easy it is to get there? How easy it is for me to know where I am and how to get back to where I came from?

Some e-designers are calling themselves "information architects." It sounds more complex than "information designer," but it is something designers have been doing for many years, as David Sless clearly put it in an electronic exchange with another colleague. Information design involves both the organization of the information and its visual presentation. These are two distinct tasks: one dealing fundamentally with content, the second fundamentally with form. In the computer environment, as in any other, those aspects are crucial for the construction of a good communication.

It is quite delicate to design for electronic media because there is no long tradition with it. Conventions are still being established, and many of the existing ones are not user-centered. This is a field where it is indispensable to know the language of the audience, and to speak in plain language. Steve Krug makes a number of sound suggestions, all dealing with common sense in both verbal and visual terms.

It is important to learn how and in what ways different groups of people use the World Wide Web. There are, however, several common features. People tend to want to get to wherever they want easily and quickly. Instructions, therefore, must be both clear and brief. Clarity should not be sacrificed for the sake of brevity. One of the interesting things in visual communication design is that it requires judgment at every stage.

Some people might think that it is not up to the designers to concern themselves with texts. However, since we are responsible for the communicational success of the things we design, we should be able to advise clients and production teams in connection with the communicational effectiveness of written material. We should do this even if we are not able to write or edit.

Concern about the comprehensibility of texts, beyond legibility, arose in the 1960s through the work of Herbert Spencer, who introduced the concept of readability to the evaluation of the visual presentation of texts. Merald Wrolstadt, founding editor of *Visible Language* (now edited by Sharon Poggenpohl), dedicated the journal to a whole range of issues that related to the visual presentation of texts. Following this tradition, and understanding our responsibilities in connection with the usability of information, it is natural for a designer to be concerned with the structure of language as it appears in the electronic media. Texts, particularly when used to guide the user, should be brief, clear, and written in easily understandable language.

In addition, we should be aware that people like shortcuts. Users should be able to see at a glance the "place" they want to go to. On the basis of Appleton's work, it is useful to see how the notion of "prospect" can be important for the design of interfaces. Appleton suggests that people have a biologically and historically programmed need to perceive the landscape around them. This, he claims, comes from the time when our ancestors were surrounded by potential dangers and needed to have their backs covered while being able to see everything around them. This may have led people to inhabit caves up in the hills, once they were inspected and known to be safe; their height on the hillside allowed people to see far and wide. We are visual animals: all of our civilization has been supported by vision, not by sound or smell. It was this reliance on vision that led us up into the hills in the first place.

Stan Ruecker has just completed his doctoral thesis (under my co-supervision, with colleagues in the English and Computer Science Departments) on interface design in the context of Appleton's and Gibson's concepts of prospect, refuge, and affordance. In the case of the computer environment, we need to design in ways that allow people to visualize their location, and the kind of "landscape" that surrounds them. I am not using these metaphors just to be poetic. Lakoff and Johnson (1980, 1987) have clearly argued the importance of metaphors in the development of abstract thinking.

There is much terrain to be covered in connection with the usability of interfaces, and criteria are being

developed by different people working on cognitive human factors as they apply to interface design. Bonnie Sadler Takach, in collaboration with Jason Daniels and Connie Varnhagen of the Psychology Department at the University of Alberta, developed interfaces to test the effects of text-based and

145. Bonnie Sadler Takach, Jason Daniels, and Connie Varnhagen (2000), test materials for Web site navigation design. (Reproduced by permission, © Bonnie Sadler Takach)

metaphor-based interface design on time and recall in World Wide Web navigation (Figure 145).

Interdisciplinary work is indispensable today: it requires designers to have some understanding of experimental research, and it requires psychologists and other human factors specialists to have some understanding of design. We designers are geared toward the production of objects. Researchers, on the other hand, are acute observers and master sophisticated methods. We need situations where the integration of design and research becomes possible, beyond the traditional separation of disciplines that is so common in universities.

There are visual languages and conventions that have been developed to visually explain the structures of sites and possible paths to follow in these virtual environments. New conventions of movement and representation allow interaction using hybrid visual languages developed in both print and electronic media (Figures 146 to 151).

In sum, interfaces in the computer environment should clearly show the contents of their data bank, the hierarchical organization of the contents, and the navigation tools. In general, they should permit people to act intuitively, glancing and guessing.

There are, of course, diverse fields in the design of electronic media, including (1) the commercialization of consumer goods and services, (2) governmental information, and (3) educational materials.

146, 147, and 148. Dynamic Diagrams (1990s), interface design. (Reproduced by permission, © Krzysztof Lenk)

149. Dynamic Diagrams (1996), *Britannica on Line,* Web site structure map. (Reproduced by permission, © Krzysztof Lenk)

150. The first screen of the Web site for Meta Design, in 2002. A user-friendly Web site with a strong identity, and easy to navigate. (Reproduced by permission, © William Hill)

151. Automobile Association, UK (1990s), CD-ROM, routes and tourist information.

Among the consumer-oriented sites, one of the most popular in the university community is *www.amazon.com*. Amazon has worked hard to create an interface that any book reader can operate. The government of Canada, among others, now has a whole range of services through the Internet where one can find information and download forms without interacting with employees, telephones, or the postal system. Educational materials for distance education or for the support of regular courses have also modified the administration of instruction, delegating to the electronic media a whole range of

Research display

152. Research display in the cockpit of the NASA Boeing 757 Airborne and Integrated Experiment System (ARIES) (Reproduced by permission, Tim Etherington, for Rockwell Collins.)

materials, and reserving personal meetings for discussion and group interaction.

When discussing electronic communications, one should not forget the design of control panels for machinery and transportation applications, from the dashboard of a passenger car to the cockpit of an aircraft. This is a critical field where designers have seldom been present, even though, in the late 1950s, the design school of Ulm under Maldonado, Gugelot, and Aicher started to work on the problem (Cantz 38, 164). There is an urgent need to identify those areas where our visual training and our concern for a user-centered approach to design could contribute

significantly to the quality of interfaces in many different contexts (Figure 152).

This is a fast-growing field that has significantly affected visual communication design in both production and conception. It has also created new communication channels for information, education, and entertainment, opening a wide range of possibilities for the development of visual communication design.

Culture and Society

SOCIETY DEVELOPS WITHIN A PERMANENT
flow of information exchange. The mass media, the
urban environment, and public transportation are active
sources of information that both express and build
culture. Journalism and advertising create cultural
models of appearance and behavior, promoting choices,
lifestyles, and cultural values. A cursory review of some
publications shows how cultural consensus is built, how
social roles get defined, and how a cultural language is
constructed within a society. Through this analysis,
cultural values become evident. The value of health is
quite common to many societies, but it is especially
strong in ours. More religious societies do not value
health that much. When people strongly believe in the
afterlife, not much importance is placed on health or
the fear of death. We pursue health through personal
care and through science.

The visual language developed by a culture includes
the codification of color. In our society, science tends

to be portrayed as blue or magenta, because green goes to ecology and beige to healthy, natural foods. The look of science is strongly related to chemistry and physics. In the context of advertising, science, technology, and health meet to create myths. While no one believes in miraculous medicines, apparently myth-based advertisements work, because they are commonly used.

Another important value in our society is wealth. Without necessarily going as far as luxury, a look at advertising in mass media shows that a solid financial grounding seems to be a need in our culture.

Mass media contribute substantially to defining gender. Whereas general news magazines show women in more varied roles, most magazines for women dwell on fashion, sexuality, and a narrow definition of femininity. Sports magazines are mostly for men and about men, and they portray athletes as models of masculinity, offering a narrow definition of masculinity as well. Sometimes even cars stand for traditionally masculine values. Money and power are provinces where men prevail, and much editorial space is dedicated to male politicians or business leaders. There are different ways in which these roles are depicted by the media: The Italian magazine *L'Espresso* constantly portrays politicians in a non-flattering way, removing pomp from the public perception of their roles. One should not oversimplify our era by looking at only two or three publications. We are exposed to many TV channels, printed publications, and films that constantly build and broadcast cultural models.

Freedom, power, control, pleasure, self-reliance, financial success, fitness, luxury, and leisure take center stage in Western mass media in association with news, services, products, and ideas to sell or to persuade. The designer needs to tread lightly in this terrain. We have to be conscious that our work contributes to the shaping of the world we live in.

In a relatively recent development, social marketing has extended the traditional field of communication design. While there have been people with good intentions for many years, communications oriented toward addressing social problems were developed in a naïve way. It was thought that merely mentioning the problem was enough to make it go away. We have now adopted and adapted the experience of commercial advertising, and put it in the service of the public good. I believe that this area is bound to grow dramatically in the next few years. Some governments are discovering that certain social problems, such as traffic and industrial injuries, cost countries billions of dollars a year. The health care system in Canada spends about $15 billion a year looking after the injured, while 51 million workdays are lost to injuries in the country. Fifty thousand Americans die every year in traffic collisions (the same number who died during ten years of war in Vietnam).

The state of Victoria, in Australia, after investing $6 million in a traffic safety campaign, saved $118 million in insurance compensations, and it is estimated that, computing other related costs, the community saved

an additional $360 million (Grey Advertising 191). There is much to do in this terrain, and communication design is a useful tool when applied with intelligence toward the reduction of social problems of many kinds. Leaving tragedies aside, even in the innocent field of the design of forms, there is quite a bit of money to be saved. The Communication Research Institute of Australia estimates that, in the United States, every error made by an American taxpayer on a tax form costs that person $10 to fix in administrative time. Better forms could reduce the number of errors, and eliminate the subsequent high cost of correction.

The financial dimension of these problems has been discovered in some places, reminding governments that doing nothing is far more expensive than organizing well-researched and well-executed massive communicational campaigns.

Conclusion

VISUAL COMMUNICATION DESIGN CAN BE,
as noted at the beginning, both an activity and a
product. It is the activity of conceiving, planning,
projecting, and producing visual communications,
normally implemented through industrial means, and
oriented at broadcasting specific messages to specific
publics. This is done to obtain a reaction, connected
to the knowledge, the attitudes, the feelings, or the
behavior of the public. A design is an object created
by that activity.

Communication design is social science, art,
technology, and craft. It is a social science because it
is always aimed at people, and psychology, sociology,
and anthropology have much to offer to the
construction of effective communications. It is an art
because it deals with forms and requires awareness of
and sensitivity to the visual languages of people and
places. It is a technology because it is always produced
by industrial means. And it is a craft because the

technology used requires an understanding that cannot rely exclusively on the machines that implement it. Design is an intellectual, sensitive, and practical discipline, requiring many levels of human activity: power of analysis, sensitivity to difference, mental flexibility, interpersonal skills, clarity of judgment, visual sensitivity, cultural awareness, and technical knowledge. In today's society, where information is a key commodity, the importance of visual communication design is only limited by the quality of the designers.

Given the visual nature of our culture in general, and the increasing volume of visual information in particular, visual communication designers can make substantial contributions to the clarity, effectiveness, beauty, and economic viability of the ever-growing flow of information. They can facilitate this flow and contribute to the quality of our society and our life.

Bibliography

Alexander, Christopher. *Notes on the Synthesis of Form.* Cambridge, Mass.: Harvard University Press, 1979.

Appleton, J. *The Experience of Landscape.* London: John Wiley, 1975.

Barthes, Roland. "The Rhetoric of the Image." *Image, Music, Text.* New York: Hill and Wang, 1977.

Bonsiepe, Gui. *Interface: An Approach to Design.* Maastricht, Netherlands: Jan van Eyck Akademie, 1999.

Cantz, Hatje (ed.). *Ulmer Modelle/Modelle nach Ulm.* Ulm, Germany: Ulmer Museum/hfg-archiv, 2003.

Crosby, Theo, Fletcher, Alan, and Forbes, Colin. *A Sign System Manual.* New York: Praeger Publishers, 1970.

Cross, Nigel, and Roy, Robin. *A Design Methods Manual*. Milton Keynes, UK: Open University, 1975.

Easterby, Ronald, and Graydon, I. R. *Evaluation of Public Information Symbols, ISO Tests 1979/80 Series, Report 70*. Birmingham, UK: University of Aston, 1981.

Easterby, Ronald, and Zwaga, Harm. *Evaluation of Public Information Symbols, ISO Tests 1975 Series, Report 60*. Birmingham, UK: University of Aston, 1976.

Frascara, Jorge. "Pattern Design and Literacy for the Retarded." *Icographic* 14 (1979), 14–15.

———. "Graphic Design: Fine Art or Social Science?" In Margolin, V. and Buchanan, R. (eds.), *The Idea of Design*. Cambridge, Mass.: MIT Press, 1995.

———. *User-centered Graphic Design*. London: Taylor & Francis, 1997.

———. "Information Design and Cultural Difference." *Information Design Journal,* vol. 9, no. 2/3 (2000): 119.

——— (ed.). *Design and the Social Sciences: Making Connections*. London: Taylor & Francis, 2002.

Frutiger, Adrian. *Type Sign Symbol*. Zurich: ABC Verlag, 1980.

Gorb, Peter. "Using Design." In Gorb, Peter (ed.), *Living by Design*. London: Lund Humphries, 1978.

Goudy, Frederic. *The Alphabet and Elements of Lettering*. New York: Dover, 1963.

Grey Advertising. "Road Safety: The Transport Accident Commission Campaign." Advertising Federation of Australia. Cited in *Effective Advertising*. Sydney: Southwood Press, 1990.

Heller, Steven, and Ballance, Georgette. *Graphic Design History*. New York: Allworth Press, 2001.

Hofstadter, Douglas. *Gödel, Escher, Bach*. New York: Vintage, 1979.

Huff, William S. "*Grundlehre* at the HfG—with a Focus on the '*Visuelle Grammatik*.'" In Cantz, Hatje (ed.), *Ulmer Modelle/Modelle nach Ulm*. Ulm, Germany: Ulmer Museum/hfg-archiv, 2003.

Johnson, Mark. *The Body in the Mind*. Chicago: University of Chicago Press, 1987.

Krug, Steve. *Don't Make Me Think*. Indianapolis: Que/McMillan, 2000.

Ladan, Carol, and Frascara, Jorge. "Three Variables Influencing the Picture Preferences of South and North American Boys and Girls." *Reading Improvement*, vol. 14, no. 2 (1977), 120–28.

Lakoff, George, and Johnson, Mark. *Metaphors We Live By.* Chicago: University of Chicago Press, 1980.

McConnell, John. "Jobbing graphics." In Peter Gorb (ed.), *Living by Design.* London: Lund Humphries, 1978.

McLuhan, Marshall. *Understanding Media.* New York/Toronto: McGraw Hill, 1964.

Meggs, Philip. *A History of Graphic Design.* New York: Van Nostrand Reinhold, 1983.

Mijksenaar, Unger. "Signposting and Communication Media." *Icographic* 7. (1974).

Mullender, J. *Guide Pratique sur le Design Graphique.* Paris: Centre Georges Pompidou, 1979.

Nelson, T., Nilsson, T., Piercey, D., Johnson, T., Frascara, J., Silva Delano, S., Susuki Sone, E., and Villalon Bravo, M. "Improving Perception of Letters and Visual Structure of Language." *Perceptual and Motor Skills* 88 (1999): 515–530.

Ogilvy, David. *Ogilvy on Advertising.* New York: Crown Publishers, 1983.

Petit, Philip. *The Concept of Structuralism.* Los Angeles: University of California Press, 1977.

Pujol, Mónica. Public lecture, "Design as a Social Practice," University of Alberta, November 2001.

Rose, Stewart. "Stamp on It—Some Aspects of Postage Stamp Design." *Icographic* 8. (1974).

Sanders, Elizabeth. "From User-centered to Participatory Design Approaches." In Frascara, Jorge (ed.), *Design and the Social Sciences: Making Connections.* London: Taylor & Francis, 2002.

Sinclair, S., Moore, S., Lavis, C., and Soldat, A. "The Influence of Affect on Cognitive Processes." In Frascara, Jorge (ed.), *Design and the Social Sciences: Making Connections.* London: Taylor & Francis, 2002.

Spencer, Herbert. *The Visible Word.* New York: Hastings House, 1969.

Theunissen, E., and Etherington, T. "Computer Graphics in the Cockpit," *Information Design Journal,* vol. 11, no. 1 (2002), 4–16.

Tubbergen, Haukje. *La Femme et la Publicité.* Eindhoven, Netherlands: Icograda and the Technische Hogeschool Eindhoven, 1976.

Tufte, Edward. *The Visual Display of Quantitative Information.* Cheshire, Conn.: Graphics Press, 1983.

Wildbur, Peter, and Burke, Michael. *Information Graphics.* London: Thames & Hudson, 1998.

Woodham, Jonathan. *Twentieth-Century Design.* New York: Oxford University Press, 1997.

Wright, Patricia. "Informed Design for Forms." *Information Design Journal,* vol. 2, no. 3/4 (1981): 151–178.

Index

Books from Allworth Press

Allworth Press is an imprint of Allworth Communications, Inc. Selected titles are listed below.

American Type Design and Designers
by David Consuegra (paperback, 9 × 11, 320 pages, $35.00)

Teaching Graphic Design
edited by Steven Heller (paperback, 6 × 9, 304 pages, $19.95)

The Education of a Graphic Designer
edited by Steven Heller (paperback, 6¾ × 9⅞, 288 pages, $18.95)

The Education of an E-Designer
edited by Steven Heller (paperback, 6¾ × 9⅞, 352 pages, $21.95)

Graphic Design History
edited by Steven Heller and Georgette Balance (paperback, 6¾ × 9⅞, 352 pages, $21.95)

Editing by Design, Third Edition
by Jan V. White (paperback, 8½ × 11, 256 pages, $29.95)

The Elements of Graphic Design: Space, Unity, Page Architecture, and Type
by Alexander White (paperback, 6⅛ × 9¼, 160 pages, $24.95)

Citizen Designer: Perspectives on Design Responsibility
edited by Steven Heller and Véronique Vienne (paperback, 6 × 9, 272 pages, $19.95)

Inside the Business of Graphic Design: 60 Leaders Share Their Secrets of Success
by Catharine Fishel (paperback, 6 × 9, 288 pages, $19.95)

Looking Closer 4: Critical Writings on Graphic Design
edited by Michael Bierut, William Drenttel, and Steven Heller (paperback, 6¾ × 9⅞, 304 pages, $21.95)

Please write to request our free catalog. To order by credit card, call 1-800-491-2808 or send a check or money order to Allworth Press, 10 East 23rd Street, Suite 510, New York, NY 10010. Include $5 for shipping and handling for the first book ordered and $1 for each additional book. Ten dollars plus $1 for each additional book if ordering from Canada. New York State residents must add sales tax.

To see our complete catalog on the World Wide Web, or to order online, you can find us at ***www.allworth.com***.